IMAGES
of America

JONESBORO

Col. Samuel Goode Jones, civil engineer for the Monroe Railroad and Banking Company, arrived in the small settlement of Leaksville in 1843. The building of the proposed rail line from Macon to Marthasville stalled when the company declared bankruptcy. A year later, the line was completed by the reorganized Macon and Western Railroad. In the interim, Jones drew up a plan for the town, which was renamed Jonesborough in his honor. It was officially changed to Jonesboro in 1893.

ON THE COVER: This street scene featuring Bama's Drug Store and other stores along Main Street is a 1940s postcard with no informational notes at the top. Bama's was a focus of everyday life in the Jonesboro of the 1940s and 1950s. Longtime residents rate Bama Rowan's store, along with the courthouse, as the distinctive feature of the city. (Courtesy Louise Blalock.)

IMAGES
of America

JONESBORO

Historical Jonesboro/
Clayton County, Inc.

ARCADIA
PUBLISHING

Published by Arcadia Publishing
Charleston SC, Chicago IL, Portsmouth NH, San Francisco CA

Printed in the United States of America

Library of Congress Catalog Card Number: 2006930550

For all general information contact Arcadia Publishing at:
Telephone 843-853-2070
Fax 843-853-0044
E-mail sales@arcadiapublishing.com
For customer service and orders:
Toll-Free 1-888-313-2665

Visit us on the Internet at www.arcadiapublishing.com

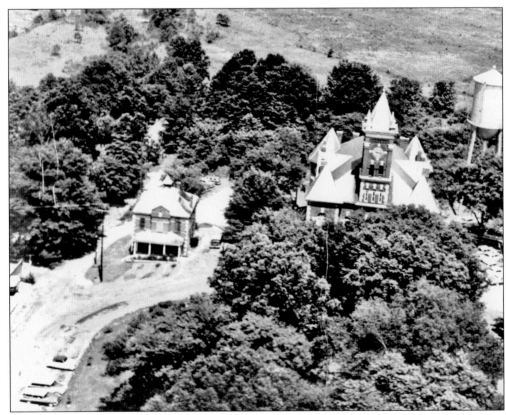

The most dominant feature of downtown Jonesboro is the 1898 courthouse (right). It is pure Victorian Gothic architecture. The clock tower presides over the park-like setting that overlooks the central business district. This aerial photograph also shows the 1898 jail.

CONTENTS

ACKNOWLEDGMENTS

On behalf of Historical Jonesboro/Clayton County, Inc., I want to express sincere appreciation to all who worked to make this publication a reality. Valerie Frey deserves special recognition, not only for the many hours that she spent scanning the images, but also for her guidance through the project. Appreciation must also be expressed to Marnye Hall for her superb editing. The executive board endorsed and supported the undertaking. The members of the book committee dedicated time and effort to collecting pictures, organizing materials, and preparing photograph captions. The members were Katherine Smith, Al Camp, Dan Hudson, Amanda Roberts, Ray Muse, Ted Key, and Carol Cook, led by the tireless efforts of our president, Barbara Emert. None of this would have been possible without the cooperation of all who shared their precious photographs and information with us. In addition to the committee members, these include Helen Barton, Jewell Betsill, Louise Blalock, Ron Brown, Elizabeth Bunnell, Joyce Crane, Virginia Freeman Ford, Marion Hodges, Lucy Huie, Lee Hutcheson, Estelle Lantzy, Robert McMullen, Roger Oakes, Grace Oliver, Ann Sligh, Sandra Starr, Lillie Suder, Linda Summerlin, Willis Swint, Elise Whaley, George Wilburn, Jimmy Wiggins, Pam Kirkland and First Baptist Church of Jonesboro, and the Clayton County History Center. Thanks to Herb Bridges for granting permission for his photograph of the *Gone with the Wind* premiere to be included in the book. Joseph Hightower Moore generously shared not only his collection of photographs but also his extensive knowledge of the people, places, and history of Jonesboro. Dr. Gene Hatfield of Clayton State College prepared the introductory material. A word of personal appreciation must be given to Don Carter for his encouragement and support. Most importantly, thanks to all the people who made the history and to those who photographed it for us to enjoy.

INTRODUCTION

As the mythical capital of *Gone with the Wind*, Jonesboro has been cast in terms larger-than-life. As the county seat of Clayton County, it is known around the world as the center of a world of romance and gallantry, which has vanished into the past. And yet the real history of this little town is almost as compelling as the story Margaret Mitchell created. The real story is often gritty and painful, partaking of wisdom and folly, good and bad, with a full measure of courage and perseverance on the part of its citizens, both black and white.

Only in the fairly recent past has the land been inhabited that today is Jonesboro and Clayton County. For much of its history, the only humans who traversed the land were hunters and tribesmen using its paths to travel between tribal villages and ceremonial centers. For centuries, it was occupied by the Muscogee Creeks, who used it primarily for hunting. By the mid-18th century and perhaps even before, white hunters and trappers began to penetrate the area more or less regularly.

Following the American Revolution, pressure increased on the Creeks from white populations moving north from coastal Georgia and east from North Carolina and South Carolina. A series of cessions turned over land owned by the Creeks to the State of Georgia. In 1821, the latest in this series was formalized in the Treaty of Indian Springs, which turned over to white settlement all of the land between the headwaters of the Ocmulgee and Flint Rivers north of the boundary of the 1814 cession and south of the Chattahootchee River. In December 1821, the legislature organized five counties from this territory, including the counties of Henry and Fayette. By 1822, settlers were beginning to move into the new counties.

In little over a year, a small settlement called Leaksville had developed in part of Fayette County. Almost a year to the day after the new counties were organized, the State of Georgia granted a charter for Leaksville Academy to be located on Academy Street. In January 1825, the Flint River Baptist Church organized to worship in a log sanctuary located near Hynd Springs, in the present city limits of Jonesboro. The church today is known as the First Baptist Church of Jonesboro.

Leaksville was located astride two roads of local importance. The White Hall Road ran between Griffin and a tavern by that name located in what is now West End Atlanta. Intersecting White Hall Road was a road connecting Muscogee Town (the site of present-day Columbus) and Stone Mountain. A Native American trail for centuries, it closely followed the present-day course of Highway 54 from Fayetteville to Jonesboro as well as portions of Highway 138 and Clayton County's Stagecoach Road.

The arrival of the railroad would mark a new era in the history of the area. In 1843, the Central of Georgia reached Macon. Long before that time, construction of the leg between Macon and the town of Marthasville had begun. As the Macon and Western Railroad drew closer to Leaksville, a post office was opened in 1842 and newcomers began to arrive, including Samuel Goode Jones, a civil engineer employed by the railroad. Jones believed that the town would grow more rapidly once it became a station on the railroad line. He applied his skills to creating a plan for the city that he hoped would help manage its growth. Not surprisingly, in 1843, the local citizens renamed

the town Jonesborough in his honor (the present spelling Jonesboro officially dates from 1893). In 1845, the first train entered Jonesborough from the south. By 1846, regular railroad service was in operation from Macon through Jonesborough and on to the town that became Atlanta the following year.

Growth was steady. The towns of McDonough in Henry County and Fayetteville in Fayette County had shown disinterest in railroad connections. As a consequence, Jonesboro became a trading center for farm goods and commodities required by the local economy. However, from the beginning, its development lagged well behind that of Atlanta, which had been planned as the terminal for four railroad lines.

In 1845, a congregation of Methodists had organized as the Jonesborough Methodist Church. In 1846, the Episcopal Diocese of Georgia established a mission in Jonesborough. When St. Philip's Episcopal Church was organized in Atlanta in 1847, its original vestry included Samuel Goode Jones and Guy Warren, the agent of the Macon and Western Railroad in Jonesborough. While Presbyterian congregations were scattered in neighboring locations, there were none in Jonesborough. There were few Catholics and no Catholic church closer than Atlanta. In 1849, the Reverend George White published Statistics of the State of Georgia. He noted Jonesborough had a population of some 200 and that, in addition to its churches, it contained three schools. He stated that "the population is improving." Five years later in White's Historical Collections of Georgia, he noted that the town was "a thriving place."

Even so, there were those who felt that their community was not growing fast enough. They sought to have the legislature create a new county out of Henry and Fayette Counties. Their efforts succeeded in November 1858. The new county was named for Judge Augustine Smith Clayton, a former jurist and member of Congress.

The census of 1860 reveals that Jonesborough was the seat of a county that like almost all other counties in Georgia depended overwhelmingly on agriculture as the foundation of its economy. Like other Georgia counties, its agrarian economy depended on slaves for much of its production. In that year, the total population of the county was 4,466 persons, of which 1,216 were slaves. Approximately one-third of the families in the county owned slaves. This, too, was more or less similar to most other Georgia counties.

As one would expect, most of the businesses in the county seat were those that would be needed to maintain an agrarian economy. There was a tanyard, a carriage-maker, a blacksmith, a wagon-maker, and a saw and gristmill. There were several physicians and four lawyers. Some of the physicians and lawyers also owned farms. In addition, there were three ministers residing in Jonesborough. A hotel and livery stable provided a place to stay for those doing business in the town. The Clayton High School conducted by Allen D. Candler, a future Georgia governor, was known throughout the area for the thorough education it provided its 63 students, 30 of which were female. In addition, there were six common schools in the county.

Most of the farmers in the area were yeoman, in other words, self-sufficient farmers who owned their own land. The majority neither owned nor utilized slaves. However, the 1860 census reveals that 171 Clayton Countians owned slaves. Of those individuals, 137 owned fewer than 10 slaves. Fifteen men owned from 20 to 40 slaves. Among that minority, Sherod Gay owned more slaves and more land than anyone in the county. He owned 39 slaves and over 2,600 acres. Philip Fitzgerald was close behind with 35 slaves and over 2,500 acres concentrated along the Flint River within five miles of Jonesboro. Although the plantation economy was not as extensive in the area of Jonesboro as it was further south in Middle Georgia, it was well established and essential to the economic prosperity of the community living in and around Jonesborough. When the war came, it would largely destroy the prosperity that Jonesborough was enjoying when the secession crisis occurred.

And the war came. Within days of Abraham Lincoln's election, Gov. Joseph E. Brown called for elections on January 2 to determine delegates to attend a convention called to decide whether or not the state would secede. The convention would begin in Milledgeville on January 16. The majority of the delegates voted for secession. However, the convention revealed considerable doubt

on the part of many delegates. For example, Clayton County sent two delegates. The delegate from Jonesboro voted against secession. Nonetheless, once secession was declared, most citizens gave their support to the Confederate government.

Quickly men from Jonesboro and environs began enlisting and departing for military service. Company E, the Clayton Sharpshooters, was mustered into service on May 30, 1861, as part of the 10th Georgia. Shortly thereafter, the unit was sent to Virginia where it became part of the Army of Northern Virginia. Four other companies would be organized in the area around Jonesboro. Two of these were infantry units that became part of the Army of Northern Virginia. One was a cavalry unit that fought with Gen. Nathan Bedford Forrest. This unit was engaged both in the Atlanta campaign and in resisting Gen. William T. Sherman's "March to the Sea." The fourth unit, the Clayton Invincible, Company I of the 30th Georgia Regiment, saw most of its service with the Confederate Army of Tennessee. Ironically this unit would be engaged in the Battle of Jonesboro.

After 1862, most able-bodied men had departed for military duty. The home front was left in the hands of older men, women, and, of course, slaves. The production of cotton sharply declined as the Confederate government required farmers to produce foodstuffs for the army. Middle Georgia became an important source of food for Confederate armies, including those in Virginia. Gradually the town and many farms took on a shabby look as repairs and maintenance were put off. Commodities once taken for granted such as sugar, tea, and coffee became increasingly difficult to obtain and eventually unobtainable. The Inferior Court, which was largely responsible for local government, took steps to provide assistance to the poor, many of whom were the wives and children of soldiers.

Despite difficult conditions, the citizens of the town were spared the full scope of the war's fury until the summer of 1864. Beginning in May, Gen. William T. Sherman launched a campaign to capture Atlanta. By July, his armies almost surrounded the city. The Union forces controlled three of the four railroads that entered Atlanta. The only rail line still available for Confederate forces to maintain communications with Atlanta was the Macon and Western through Jonesborough. Seeking to cut that line, Sherman sent 2,500 cavalrymen under Gen. Judson Kilpatrick to attack Jonesborough. On the afternoon of August 18, Kilpatrick's troopers crossed the Flint River and quickly dispersed the few Confederates defending Jonesborough. He proceeded to destroy the rails through the middle of town, the railroad depot, the courthouse, and other public buildings, along with a large supply of cotton. That evening was a wild scene with cavalrymen riding back and forth, Kilpatrick's band playing martial airs, and the fire spreading because of high winds to destroy businesses and homes. It is estimated that Kilpatrick destroyed two-thirds of the town before leaving by darkness early on the morning of August 19 in the direction of Lovejoy.

By now, he and his troopers were in desperate circumstances. By the time he arrived at Lovejoy, Confederate troops were waiting. Confederate reinforcements were arriving by rail along with cavalry units that had been sent in pursuit. Confederate forces were in position astride the old McDonough Road in position to cut off Kilpatrick's retreat. Lining up his troops stirrup-to-stirrup, Kilpatrick had the Union cavalry charge over the Confederate lines. They managed to ford the flood-swollen South River and reenter Sherman's lines at Decatur. General Kilpatrick reported that it would take the Confederates weeks to repair the rail lines he had destroyed. By August 23, Sherman could see through his glasses that trains were once again arriving in Atlanta from that line.

Sherman determined that he would strike the railroad again, only this time, he would take most of his army. Once again, the main target would be Jonesborough. On the night of August 25, Sherman began to disengage his troops from their trenches, leaving only a single corps confronting the Confederates in Atlanta. The remainder of his army would undertake a wide arc to the west before striking at the Macon and Western at Jonesborough and other points north and south. Gen. John B. Hood, the commander of the Confederate Army of Tennessee, was mystified by the disappearance of most of the Union forces. Not until August 28, did he receive reports from scouts that Union forces were in his rear. As late as the next day, he continued to believe these were only local movements of Union troops. By that time, Union forces were approaching the

Flint River. By late afternoon, Union infantry and cavalry in strong numbers were entrenched across the Flint in rifle range of the Macon and Western tracks in Jonesborough.

Finally alerted to his danger, Hood dispatched forces under Gen. William Hardee that had been entrenched to the west of Atlanta to make a forced cross-country march by night to confront the Union forces at Jonesborough. The march was a hellish exercise for troops who had been confined to trenches for weeks, were on reduced rations, and in some cases were without shoes. Units began to straggle into Jonesborough the next morning. Instead of attacking at first light as Hood had ordered, they had to wait while scattered units continued to arrive and watch as Union reinforcements continued to arrive and entrench.

By early afternoon, when the attack began, the result was a foregone conclusion. The plan was overly complicated, the execution was botched, and the Confederates suffered a quick and devastating defeat. Still convinced that the main attack would fall on Atlanta, Hood ordered Hardee to return half of his forces to Hood in Atlanta. That evening, Hardee spread his remaining forces from the vicinity of the Warren House on the north along the railroad tracks to near College Street on the south. He awaited attack the next day by overwhelming forces. Fortunately for Hardee, there was no attack until the afternoon, and when it came, only a portion of the Union forces participated. Two more Union attacks were also piecemeal efforts, and the Confederates held on. That night, Hardee and his troops slipped away to Lovejoy, where they were joined the next night by Hood and the remainder of the Confederate forces. The defeat at Jonesborough had forced Hood to evacuate Atlanta. The Battle of Jonesborough was literally "the key that unlocked Atlanta."

While the battle was not one of the largest of the Civil War and its casualty count not as high as others, few battles rival Jonesborough for the significance of its consequence. As Sherman wrote in his memoirs, "Success to our arms at that instant was therefore a political necessity. . . . The brilliant success at Atlanta . . . made the election of Lincoln certain." And the *London Times* observed that "compared with the great battles of the war, the action at Jonesborough is little more than a skirmish. Yet it has been more decisive in effect than all the fighting and bloodshed of Grant's campaign."

—Dr. Gene Hatfield

The impact of the war on the local economy and citizenry of Jonesboro created a strong memory, and many of its stories were told repeatedly to the children and grandchildren of those who survived. Some of those stories struck the mind of a young girl who would later relay them to the world in an epic novel that still resonates today, shaping the "history" of Jonesboro and Clayton County as it is experienced by the throngs who come to this quiet community in search of the elusive "Tara."

But the true history of Jonesboro resides in its people—a determined, hard-working, self-sufficient lot who struggled to get through each day but found the time for the enjoyment of their collective company at church socials, picnics, dances, and other events where the young men met young women; love was born; and the life and livelihood of the community continued to evolve. Jonesboro fared well through turbulent times, a place where any man "worth his salt" was respected and appreciated, whatever his race, ethnicity, or financial status. Education was then and is today regarded very highly, and the area prospered in the growth of those facilities, to the enrichment of both the individual and the community.

To our benefit, the proud people of Jonesboro have remained loyal to their homes and their posterity. By sharing their treasured family photographs, they have graciously allowed us to take this journey through the history and the lives of the city and its people. These pictures are a treasure for the eye in their simple beauty, which so many of us enjoy enough for the chance to revel in seeing them for the first time. But their deeper beauty lies in the stories they tell, in the stirring of our own cherished memories, and the beauty they portray in the strength and determination of a proud people.

—Historical Jonesboro/Clayton County, Inc.

One

Early Days and Pioneers

There are few photographs of Jonesboro from the 19th century. Early photographs were made using the wet-plate method and required the use of bulky mahogany cameras and noxious chemicals. Photographers routinely erased their negatives to recycle the expensive glass plates. Outdoor photographs and portraits were expensive, and most families rarely indulged in this vanity. Many of the earliest photographs were single copies and have been lost to decay or family migration.

In 1888, George Eastman revolutionized photography with his Kodak camera and gelatin-emulsion roll film. In this new style of photography, people captured the images of the things in their lives that mattered the most, usually their families, homes, and businesses.

Photography was not an overnight sensation in Jonesboro. The town was just beginning to climb out of the ashes of the Civil War. Reconstruction was not easy on Jonesboro, and the town carried the scars of war and Reconstruction into the new century.

At first, only a few families could afford the luxury of a Kodak camera. By the Roaring Twenties, however, camera, film, and processing prices had decreased dramatically, and many of Jonesboro's families were snapping away.

Jonesboro has been the home of many memorable people. The images in this section represent only a brief glimpse of the array of unique and interesting people who have called Jonesboro home. These people were the predecessors and the ancestors of Jonesboro's current residents. They knew one another and interacted almost on a daily basis.

Current residents and visitors must think that it is quaint to refer to homes as the "Stewart Brown Home" or the "Johnson-Blalock House." To those who love this town, however, these designations are merely an attempt to honor the city's history and remember the colorful characters of the past.

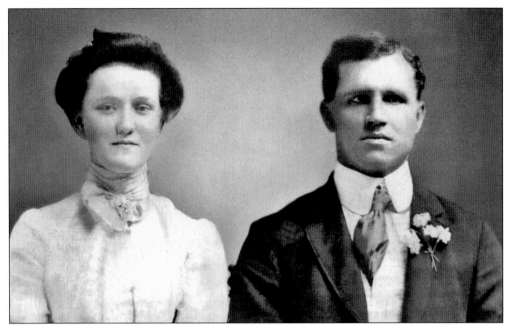

On August 6, 1904, Nellie Brown married Jonesboro merchant William Venable Whaley at the First Baptist Church. At age 10, Whaley went to live with the W. T. Sims family and worked in the Jonesboro Mercantile, which he would eventually purchase. Mary Sims taught Whaley by lamplight. He served two terms as Jonesboro's mayor and one term as the senator representing the 35th District.

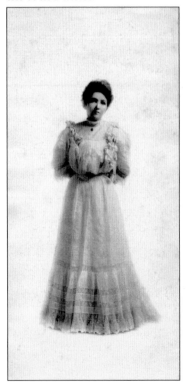

Flon Morrow is shown in this unique "costume picture" made in the 1890s. Morrow later married Lumpkin Jones. This photograph displays the prosperity that many Jonesboro families enjoyed from the 1890s until the Great Depression. The local newspapers, the *Jonesboro News* and the *Jonesboro Enterprise*, published reports of elegant social functions, some of which extended over several days.

Laura Ethel Waldrop posed for her wedding picture before her marriage to John Fieman Suttles in October 1907. She was highly educated for the time period, having attended the local Middle Georgia College; Chicora College in Greenville, South Carolina; Georgia State Normal College in Athens, Georgia; and an unknown business school. She was secretary to the vice president of the Great Atlantic and Pacific Tea Company for many years.

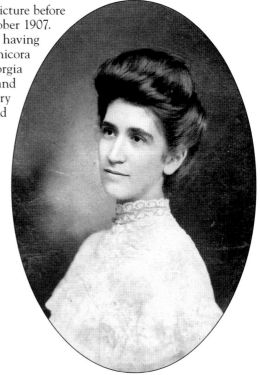

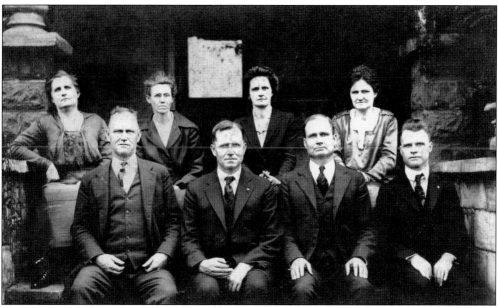

The children of Charles Loyd Whaley I and his wife, Mattie Mundy Whaley, sat for a picture in the summer of 1920. Pictured from left to right, they are as follows: (first row) Andrew Jackson Whaley, William Venable Whaley Sr., George H. Whaley, and Charles Loyd Whaley II; (second row) Odie Whaley, their cousin Angie Jones Camp, Leila Whaley Camp, and Decie Whaley Hughes.

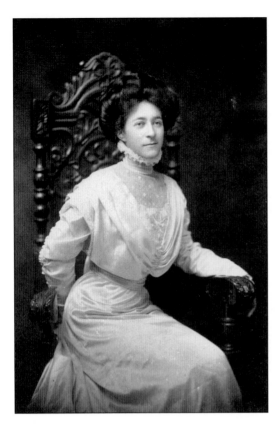

Nettye Bird Vincent wore this elegant wedding dress at her marriage to Joseph Brown Waldrop in December 1908. The lavish affair at the Methodist church was called one of Jonesboro's weddings of the decade. The bride and groom, who were both from prominent families, attended Middle Georgia College, which existed in Jonesboro from 1879 until 1900.

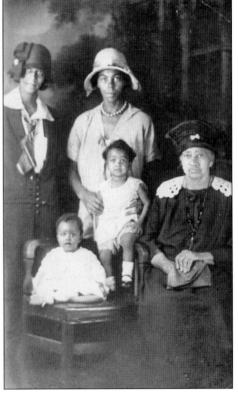

Pictured from left to right are (first row) Eddie Wilburn, Ida Mae Wilburn, and Laura Burnett; (second row) Laura McLendon and Ida Burnett Wilburn. Ida Mae and Eddie Wilburn are the great-grandchildren of Samuel Wilburn. Samuel is listed in the 1860 Clayton County census as a freed black man. He was a shoemaker. Wilburn Street, which runs off Stockbridge Road, was named in honor of one of the first African American landowners in Jonesboro.

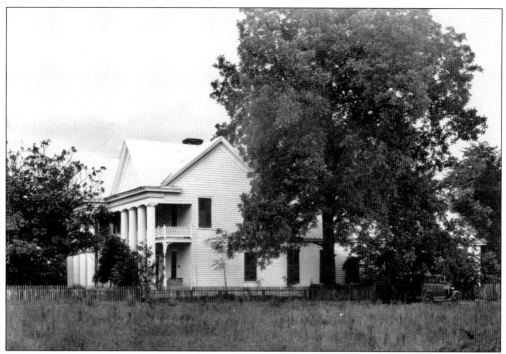

When the Civil War reached Jonesboro, one of Jonesboro's most respected physicians, Dr. Francis T. Gayden, was named chief medical officer. He declared this home and several others in the vicinity to be hospitals, surgeries, or surgeon's rests. His efforts spared the beautiful Johnson-Blalock home, pictured here in 1929.

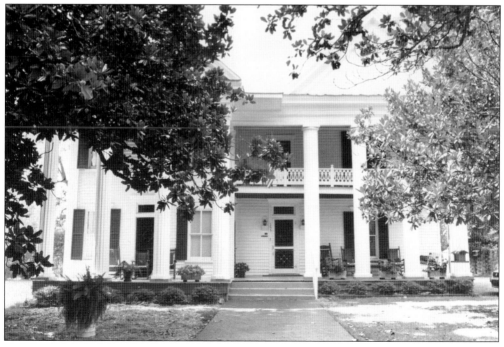

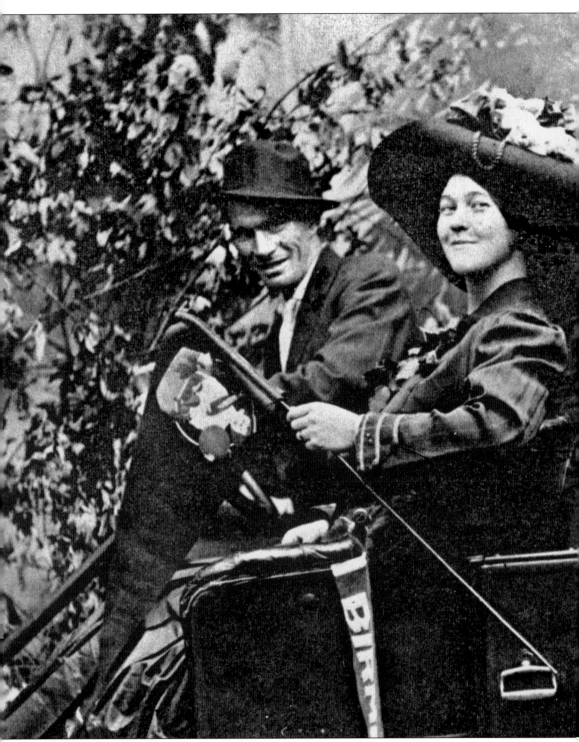

The Vessell sisters and their dates are pictured here "going-a-courting," perhaps after a football game or a drive in the country and a picnic. Pictured from left to right are Wootson Thomas and Lennie Vessell, Roy Roberts and Mae Vessell, and Ora Vessell and Henry Roberts. Mae Vessell

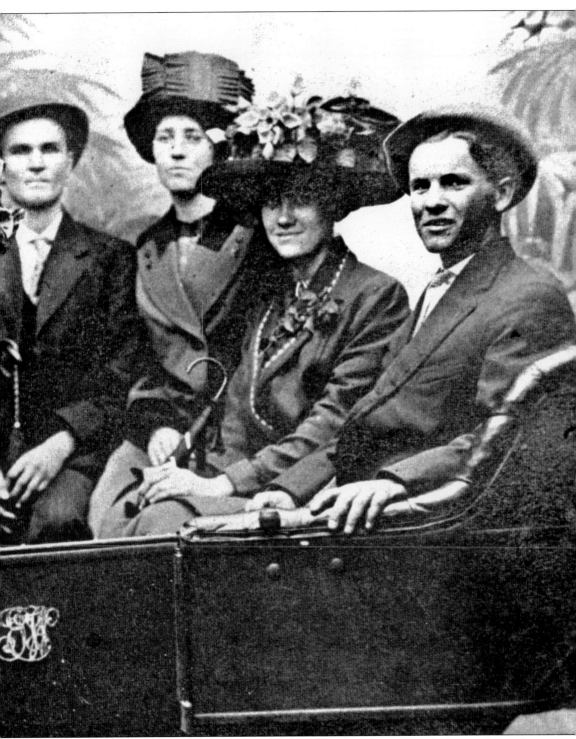

was betrothed to Ray Roberts. After losing an arm in a sawmill accident, Roberts reluctantly broke off the engagement, fearing that he could not provide adequately for his beloved.

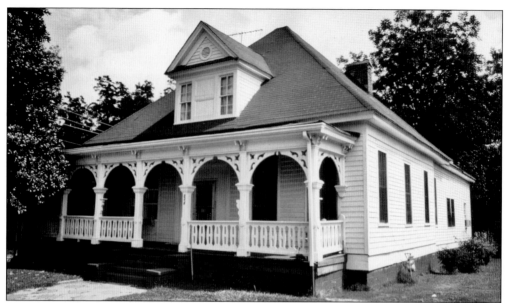

Stephen Carnes built this house at 154 North McDonough Street in the 1850s (above). He operated his wagon business behind the house. The elaborate Gothic trim was made in his wood shop. In 1866, Carnes purchased the Col. Thomas Allen plantation (below) outside of town. Some Jonesboro families evacuated to this house at the time of the Battle of Jonesboro. Carnes again used his woodshop to make fancy gingerbread trim for porches to replace those in the original classic style. The upstairs portion of this house was not completed and was used only for storage for many years. In 1872, Carnes was hired by the state to make wooden caskets for soldiers who had been buried where they fell during the Battle of Jonesboro. He disinterred and reburied the Confederate soldiers, with help from a former slave named Tom, at what is now the Patrick R. Cleburne Confederate Cemetery.

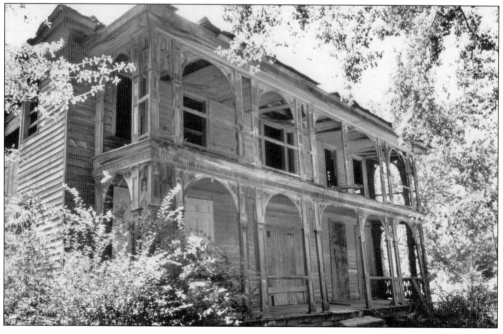

George Benjamin Davis Medlock was born January 1, 1863, in Lovejoy, Georgia. He married Caroline Ophelia Hamilton in 1888. In 1900, he moved the family to Jonesboro to ensure a good education for their nine children. Medlock was a farmer and a carpenter. In 1905, he assisted in the construction of the Jonesboro Methodist Church. He also served as mayor pro tem of the Jonesboro City Council. Caroline was active with sewing and knitting for the soldiers during World War II, in which all three of her boys served. The Medlocks were proud of letters they received from Pres. Franklin D. Roosevelt commending them for the military service of their sons as well as for their large purchases of war bonds. The top photograph was made soon after the Medlocks moved to Jonesboro. Below is a photograph from shortly before George's death in 1947.

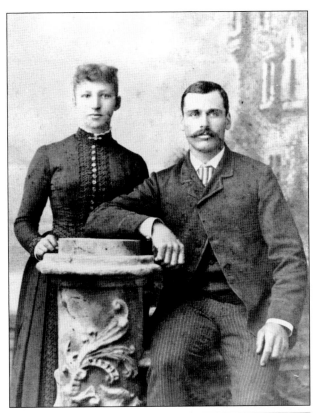

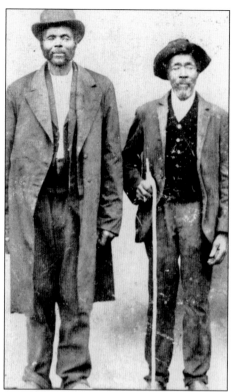

Anderson Freeman (left) was born in Spalding County in 1830 as a slave. He was sold to an unknown man in Clayton County. Freeman slept at the foot of his master's bed. After emancipation, he married twice and fathered 18 children. Several of his sons acquired extensive land holdings south of Jonesboro. Later Summer Hook Road was renamed Freeman Road by Clayton County Commission Chairman P. K. Dixon.

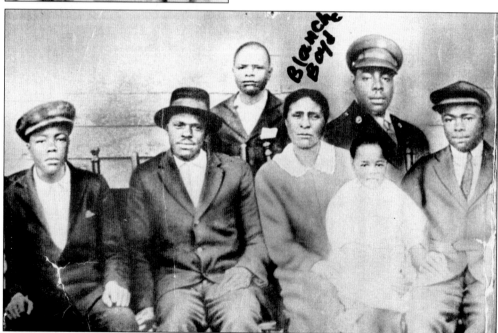

Pictured from left to right, Jafes Freeman, William Boyd, James Freeman, Blanche Mae Freeman (Boyd), Marvin Freeman (on Blanche's lap), Emmitt Freeman, and Theodore Freeman posed for this family portrait (date unknown). Blanche is the daughter of Anderson Freeman, who is pictured above.

John Patrick Oakes and his wife, Mary (Molly) Nichols, posed for this photograph about 1919–1921.

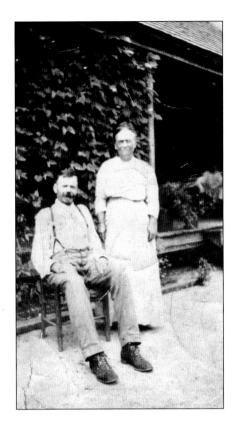

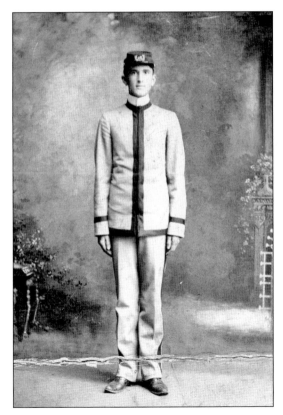

James Henderson Waldrop, son of Mr. and Mrs. J. L. H. Waldrop, is shown here as a Middle Georgia Military Academy cadet in 1899. The military school was operated by Prof. George Cleveland Looney as an adjunct to Middle Georgia College. Although it only lasted a few years, it was a predecessor to Georgia Military Academy (now Woodward Academy) in College Park, Georgia.

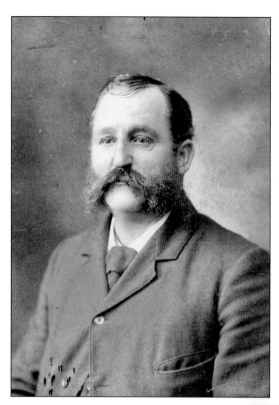

James Osgood Hightower and Matilda Anne Harris Hightower were married in November 1865. Hightower ran away from home at age 16 to join the Confederate army. After the war, he partnered with his brother-in-law Absalom Harris to establish a mercantile store. In 1874, he purchased the Jonesboro Livery Stable. He soon expanded his holdings to several Georgia counties and even held land in Texas. The Jonesboro Manufacturing Company was established by Harris and Hightower to produce cotton and silk hosiery. A generous benefactor to his community, Hightower was well known throughout the state. He held many political and civic positions, including city council member and sheriff. Matilda was active in religious, charitable, and social organizations. She was a member of the Ladies Memorial Association, which oversaw the care of the Confederate cemetery in Jonesboro prior to the organization of the local United Daughters of the Confederacy.

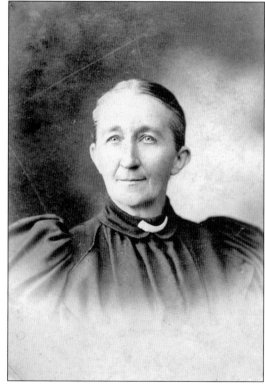

Two

MAIN STREET

Jonesboro's Main Street, from Church Street to North Avenue, is said to have been an important route before the town officially existed.

Main Street was important to Native Americans traveling along an old trail running from old Muscogee Town on the Chattahoochee River to Stone Mountain. The arrival of white settlers between 1822 and 1823 brought a stagecoach road from Fayetteville that followed this path. The stagecoaches came into town along Fayette Avenue/College Street/Church Street and exited along the Stockbridge Street/Old Stockbridge Road/Fielder Road route toward Decatur, Georgia.

Main Street grew in importance when the old White Hall–Griffin Wagon Road, possibly following another Creek Indian trail, came into town along Williamson Mill Road and exited down South Main Street. The White Hall–Griffin Wagon Road made downtown Jonesboro—or, as the town was known back then, the village of Leaksville—a likely spot for a crossroads settlement.

The railroad, following the natural watershed-dividing ridge, split Broadway Street down the middle in the early 1840s. On the west side of the tracks is the present-day Main Street, and on the east side is the current McDonough Street.

After the trains began to run in 1845, Leaksville was renamed Jonesborough, which would later be shortened to Jonesboro. Main Street continued to grow as the town's population increased, and Jonesboro became the seat of the new Clayton County in 1858.

After William T. Sherman's men razed Main Street in the fall of 1864, the present scenes through downtown Jonesboro began to take shape. This chapter provides some insight into Main Street's late-19th- and early-20th-century scenes, before the era of fast cars and fast food.

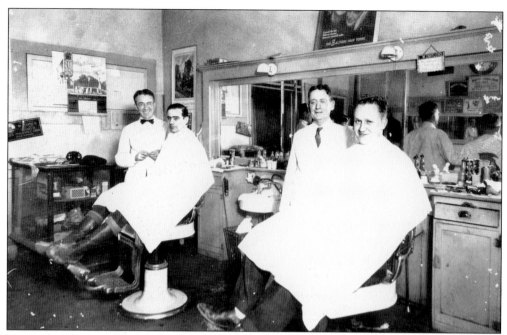

Pictured at the Jonesboro Barbershop in 1940 are, from left to right, Hoke Cartledge with Tom Donnelly and Luther "Pa Luke" Cartledge with Bill Whaley. The Cartledge father-and-son shop opened early and closed late, six days a week. Customers could get shaves, haircuts, shoe shines, and hot showers at the 119 North Main Street location.

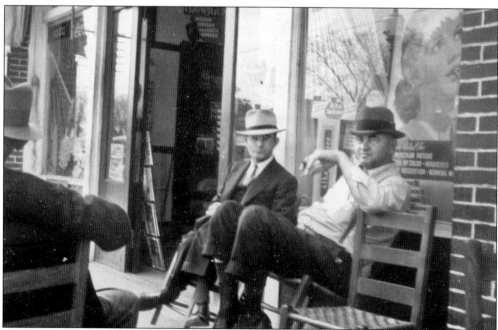

Jonesboro's longtime dentist Dr. Elbert Smith (left) and Clayton County sheriff Lamar Adamson take a break in front of the Jonesboro Drug Store, currently the location of the Heritage Bank Building. The checkerboard in the foreground is a reminder of the famous competitions often held at the drugstore.

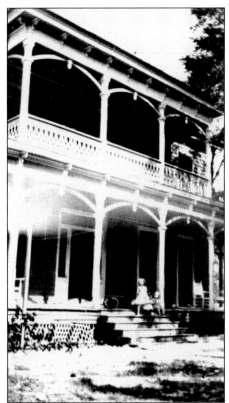

Civil War general William T. Sherman's officers were said to have taken over the house at 201 South Main Street for their quarters. James Barton Key began constructing the home in 1858 and completed the work just before the Union soldiers' arrival. The Key/Carnes/Brown house has lost its Victorian trim, but the structure survives today.

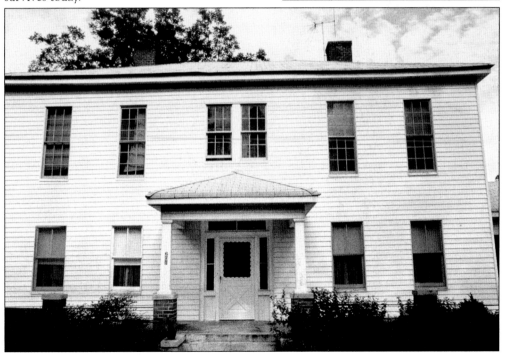

"Little Bama" Rowan held Marilyn Turner (Eason) as if she were a big rag doll at the back steps of Bama's Drug Store in 1935. This picture was taken from the "back street," or Broad Street.

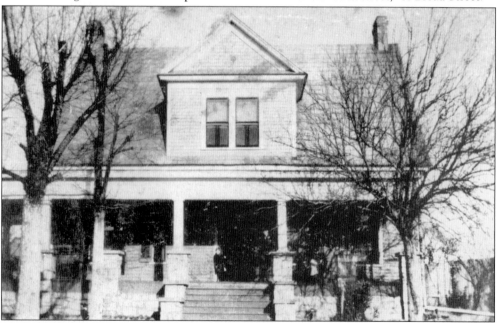

The Dollar/Waldrop/Swint House was built by Capt. Chaney A. Dollar. John Osgood Hightower purchased the home and made extensive renovations to its appearance. Hightower was a partner in Whaley and Hightower's grocery business. Later he operated a buggy assembly plant on Main Street until the advent of the automobile. He was a cofounder of the Bank of Clayton County. In 1922, he became president of the Jonesboro Manufacturing Company (later Hightower Manufacturing). During the Depression, the company closed and the bank merged with the Bank of Jonesboro.

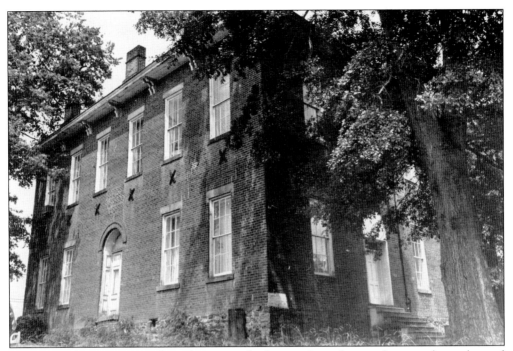

The 1869 Clayton County Courthouse was built to replace the wooden courthouse burned by Union soldiers during the Civil War. The 1869 structure is now home to the Jonesboro Masonic Lodge.

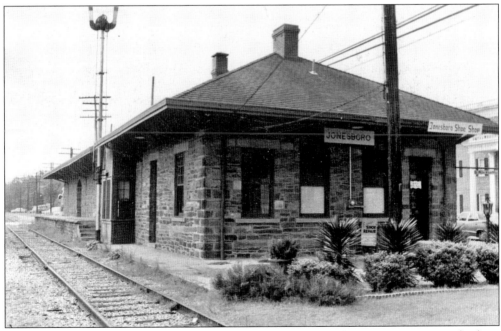

Though appearing quiet and remote in this photograph, the Jonesboro Depot was once a beehive of activity as a Central of Georgia Railroad passenger station. The depot was also home to the Railway Express Agency and Western Union Telegraph offices.

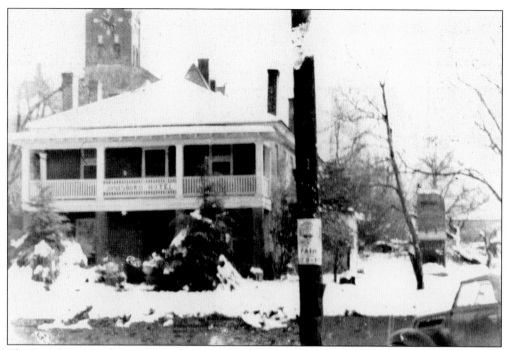

The Jonesboro Hotel once sat on the east side of the railroad on South McDonough Street. Laura McMullen owned and operated the hotel from the early 20th century until shortly after the end of World War II.

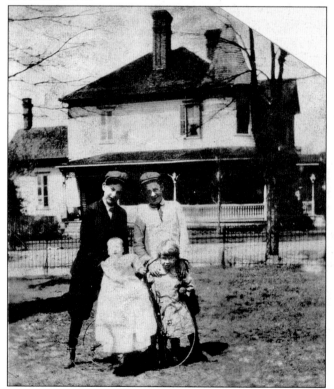

The younger children of Lon and Jenny Camp posed in their front yard at Main Street and Smith Street around 1913. They are, from left to right, as follows: (first row) baby brother Glenn and neighbor Lawrence Moore; (second row) big brothers William Eisha "W. E." and Alonga "Lonnie" Allen Jr. The beautiful old McCurdy/Dodd/Chesney house in the background is now the site of the SunTrust Bank.

Jonesboro High School seniors hang at the corner of Mill and Main Streets in 1932. They are, from left to right, as follows: (first row) Katherine King (Smith) and Elizabeth Woodward (Camp); (second row) Alice Toland and Blanche Orr (Lawrence). The Jonesboro Drug Store, in the background, was a popular after-school stop for students wanting a soda-fountain treat.

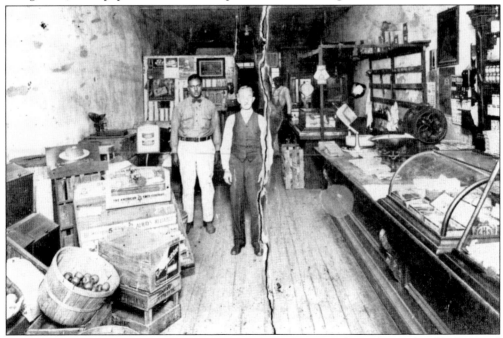

In the early 20th century, Robert "Bob" Morris (center) operated Jonesboro's first black-owned grocery store on North Main Street. He was a highly respected man throughout Jonesboro. Jonesboro resident Jenny Camp credited Morris for allowing her and her son Alonza "Lonnie" Allen Camp Jr. to find safety in the store during Jonesboro's last pistol duel, which occurred c. 1905.

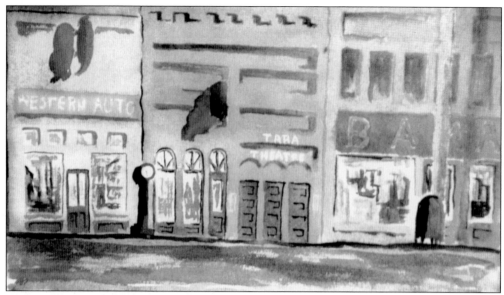

This watercolor was painted by Albert Smith. The Main Street scene of the 1950s shows the Tara Theatre, which was owned by the Burnham family. For a grand total of 80¢, a child could have taken a 1940s war-worried parent to the Tara Theatre for the matinee showing of *Gone with the Wind*. The Tara Theatre was located at 126 South Main Street, next to Bama's, where an ice cream soda after the picture could top off a memorable evening.

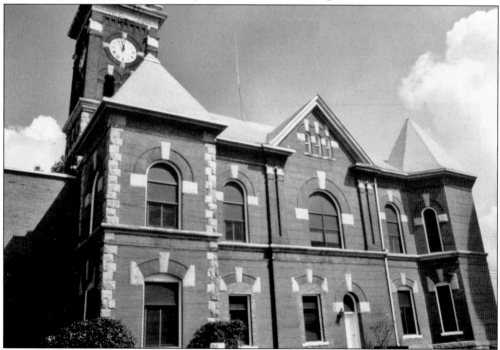

The 1898 courthouse is the focal point of Main Street. Courthouse hill, in downtown Jonesboro, has been the centerpiece of the town since 1898. For residents who grew up and lived in Jonesboro, courthouse hill is considered to be hallowed ground. In the days when Jonesboro was surrounded by farm fields, the courthouse and water tank were beacons for miles.

In this *c.* 1945 photograph, John F. Oakes, a prominent merchant on Jonesboro's downtown streets, stands in the doorway of the building at 104 North Main Street. Oakes operated his grocery stores at several locations in Clayton County, but he remained at the Main Street location until his retirement.

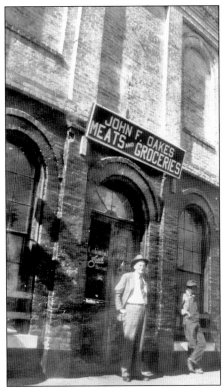

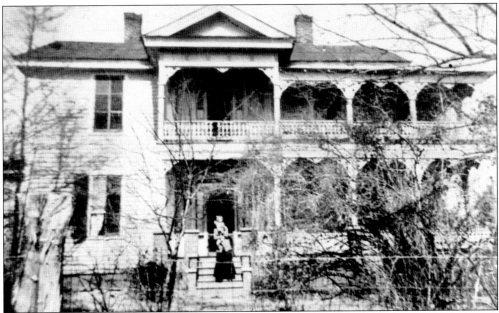

This photograph of what is commonly referred to as the Warren House was taken in 1919, when the Waldrop family lived there. At the time, it was surrounded by a picket fence and the grounds were landscaped with flowers and shrubs. The surrounding land had orchards and was farmed for cotton and grain. Society sections of period newspapers indicate that the house was frequently the site for grand parties.

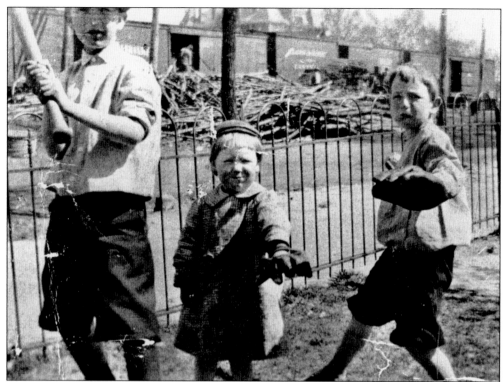

William Elisha "W. E." Camp (left), Helen Camp (center), and Hiram Edward "Hike" Camp played ball in their parents' front yard in 1912. Their parents were Lon and Jenny Camp.

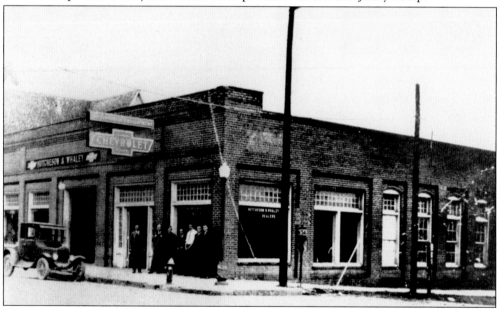

The Whaley's Amoco service station stood on the southwest corner of Main and Church Streets for many years. The site was also the home to the Hutcheson and Whaley automobile dealership. Pictured from left to right are Sam Harris, Jesse Mundy, Sara Waddy, Bill Duncan, Hubert Camp, Stancel Kean, and I. U. Wilson. The corner is now a parking lot for the Jonesboro Methodist Church.

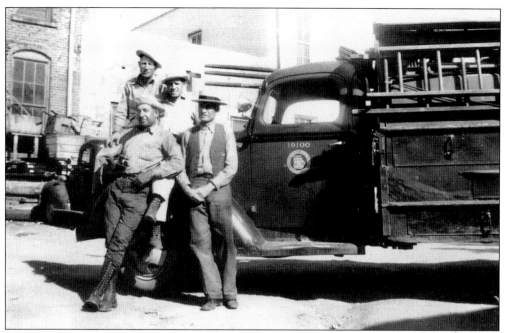

Members of the Georgia Power Company's Jonesboro line crew are, from left to right, as follows: (first row) Bloomer Lawrence and foreman Grady Woodward; (second row) Ed Haines and Ed Purdy. Here they pose on Broad Street, or "back street," behind the office (left background) on the southwest corner of Main and Mill Streets in the late 1930s.

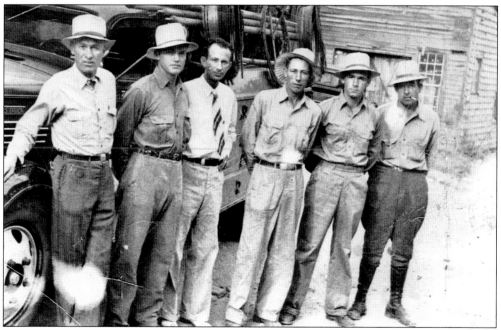

In the late 1930s, Georgia Power Company's line truck could be found off-duty on Jonesboro's Broad Street behind the local office on Main Street. Pictured about 1938, from left to right, are foreman Grady Woodward and line-crew members Jay Walker, Rayburn Sanders, Ed Haines, Tom Story, and Bloomer Lawrence.

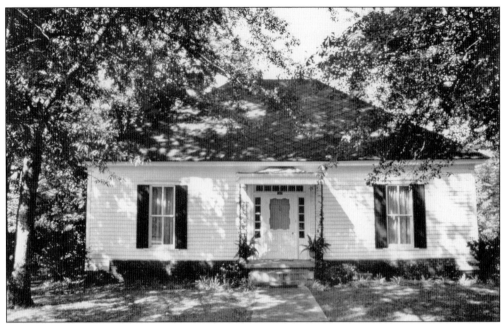

Thomas Burnside built this house in 1870 on a portion of the 1,200 acres he acquired in a state land grant. Two previous homes at this location (166 South Main Street) had burned. There is a cemetery behind the house where Thomas and other members are buried. During Kilpatrick's raid on Jonesboro in 1864, a cannonball fired from the north end of town near the Warren House killed a citizen at this location.

The Johnson-Blalock House is the only antebellum residence with two-story classical columns. It was one of many homes in Jonesboro used as a field hospital during and after the Battle of Jonesboro. In the 1890s, an itinerant artist, ? Sullivan, traded the painting of murals in the parlor for temporary lodging. The oil paintings depict flowers, birds, clouds, and the sky.

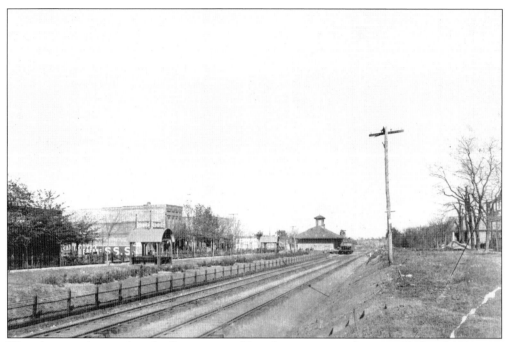

This photograph provides a bird's-eye view of Jonesboro sometime between 1890 and 1911.

Jonesboro City Hall was located next door to the courthouse until it was destroyed by fire in the 1990s. In this photograph, the building is decorated for the celebration of the 1956 Jonesboro Centennial.

This view of Main Street was taken in 1915. The photographer was standing at 211 Main Street, looking south toward downtown.

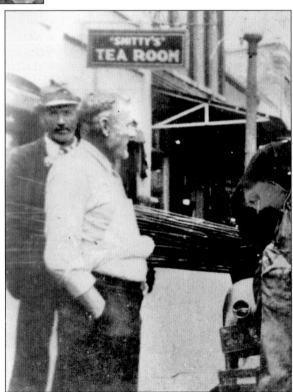

Smitty's Tea Room was a popular place to eat on Main Street.

Three
MAKING A LIVING

The early settlers in Jonesboro were mostly farmers with part-time occupations as storekeepers and blacksmiths, or sometimes as doctors and lawyers. The completion of the Macon and Western Railroad in 1845 brought new growth and business opportunities to the town. By 1860, there were 10 business establishments, including a hotel and livery stable.

Around this time, an Irish immigrant named Philip Fitzgerald, the great-grandfather of Margaret Mitchell, was the largest landowner in the county. He owned over 2,500 acres.

The Civil War and Reconstruction were hard on the residents of Jonesboro. Most of the buildings had been burned by the time the fighting ended. Former community leaders who were not killed in battle moved away to Atlanta and other towns.

However, as businesses started to reopen, a significant number started to sell liquor, and the town developed a reputation for barrooms and brawling.

Jonesboro finally pulled out of the poverty of the Reconstruction era in the early 1880s. The first local newspaper started publication. Three hotels—the Coleman House, the Turner House, and the Jonesboro Hotel—welcomed guests. For a short time, a hygienic institute promoted water cures for various ailments.

By the 1890s, Lavinia Bennett Stewart, who lived on College Street near the saloons and rowdiness of Main Street, began a campaign to close down the liquor establishments. Soon after she started her crusade, the barrooms shuttered their doors.

Jonesboro enjoyed social and economic advancement from the 1880s through World War I. After the war, both the destruction of the cotton crop by the boll weevil and the economic devastation of the Great Depression brought hard times again. These hardships and the production demands of World War II drew many citizens, especially young people, away from the town, and, by the 1950s, Jonesboro had became a bedroom community for the growing city of Atlanta.

Alonzo Herndon, an emancipated slave and young entrepreneur, peddled peanuts, molasses, and axle grease to aid his family. With a small savings, he set out on his own and learned barbering. He lived in Jonesboro from 1878 to 1883, opening his first barbershop there. He later moved to Atlanta, where he became the city's wealthiest black resident, owning barbershops and the Atlanta Life Insurance Company. Herndon wrote about Jonesboro: "It was my good fortune not only to make business progress but to gain the respect and love of the good people of this little town."

James L. Henderson (J. L. H.) Waldrop moved to Jonesboro in 1859 and joined the grocery firm of K. C. Ellington and Son. Waldrop served in the Confederate calvary and later with the home guard in defense of Atlanta and Jonesboro. His agricultural expertise was recognized with appointments to national organizations. He served on the city council and as mayor while maintaining his extensive business interests.

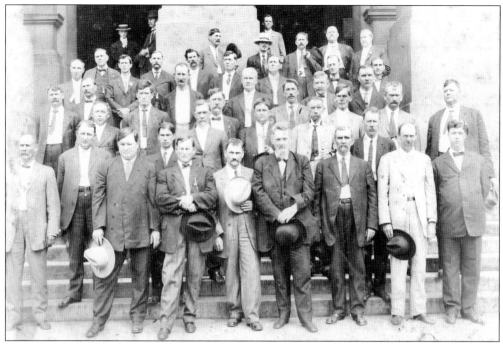

This photograph of a Georgia sheriffs' convention was taken sometime between 1910 and 1920. Representing Jonesboro were the Sheriff Charles D. Dickson and Deputy Sheriff Ed Reagan.

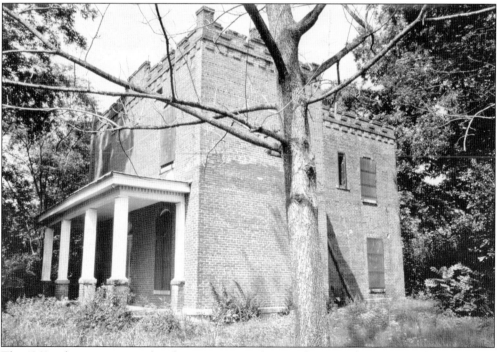

The 1869 jail was constructed at the same time as the courthouse and was among the first efforts at rebuilding during Reconstruction. It now serves as the Clayton County History Center, which is operated by Historical Jonesboro/Clayton County, Inc.

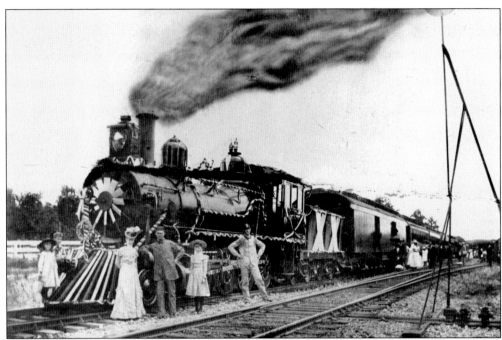

Many Jonesboro residents were able to seek employment in Atlanta when commuter-train service became available. The "Dummy" ran from Jonesboro to Atlanta two or three times a day. It was known as the Dummy because the train had to run backwards half the time due to the lack of a turnaround in Jonesboro. It was in service from 1906 to 1931.

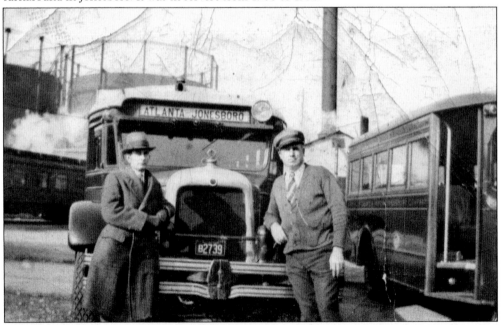

After the Dummy stopped running, Martin Ennis Estes (left) and Leon Day (right) began a bus service to Atlanta that operated from 1931 to 1939. The first bus would leave at 6:00 a.m. from Jonesboro, and the last bus to Jonesboro from Atlanta arrived at 11:00 p.m. The bus ran a full schedule six days a week and only twice on Sunday.

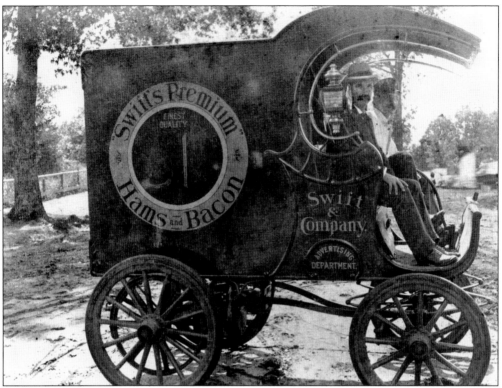

Claude H. Hutcheson in shown riding in a vehicle advertising Swifts' Premium Hams and Bacon. This photograph was taken about 1920.

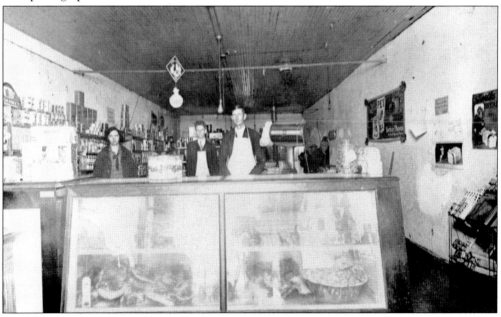

The Harris Brothers Grocery Store at 125 North Main Street boasted the first refrigerator unit in Jonesboro. Pictured in 1926, from left to right, are Addie Harris (wife of Harvey), Oliver Harris, and Harvey Harris.

Elizabeth Mary Blalock, shown at left at age two and below as a young woman, was the daughter of Joseph Edgar Ida Cloud Blalock. She was born in June 1879. After graduating from Bessie Tift College in Forsyth, Georgia, Elizabeth taught school in Danville, Virginia, and at Cox College, in what is now College Park, Virginia. Her uncle, Alfred C. Blalock, employed her at the Bank of Jonesboro, of which he was president. Elizabeth, who never married, was active in community affairs, including in the Frankie Lyle Chapter of the United Daughters of the Confederacy. After Alfred died in 1934, Elizabeth earned the distinction of being one of the first women in the United States to serve as president of a bank. She remained in that capacity until her death in March 1946.

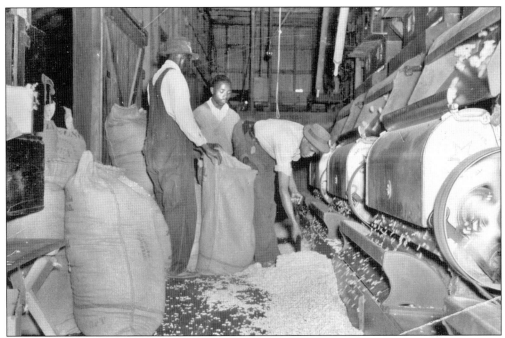

The Planters Gin and Manufacturing Company (a house gin) was built in 1917. E. J. Swint purchased it in 1933 and operated it until 1959. The men shown were picking up seeds, which were taken home to feed cows or to plant for future crops. Planters Gin was located on Mill Street. In later years, Swint Feed and Seed Store was built on the foundation. Pictured from left to right are Candy Smith, Jabo Stovall, and Glenn Naylor.

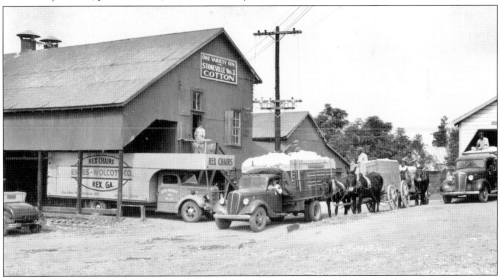

This photograph, made in the early 1940s, shows some area farmers still delivering their cotton in mule-drawn wagons. Ginner Aubrey Roberts stands on the upstairs front porch of the Planters Gin and Manufacturing Company, which was located on Mill Street. The large truck under the shelter (from Rex Furniture Company) sits under the suction pipe that would suck the cotton into the gin and then into the individual stand. The stand would pull the lint off the seed. The seeds fell into a conveyor belt, and the lint went into a press for baling.

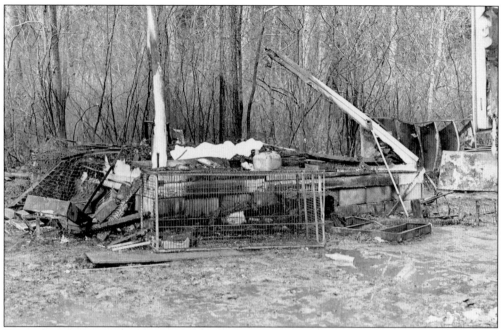

While some citizens of Jonesboro were busy making their own "corn squeezins," the law-enforcement community was hard at work seeking them out. This photograph was taken of the largest moonshine still bust in the county's history.

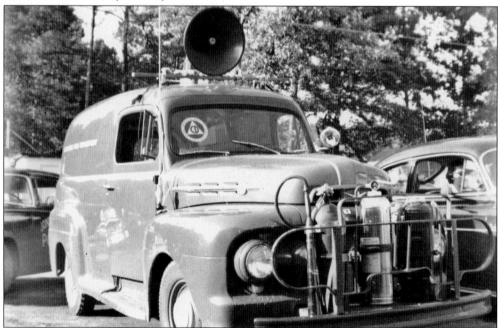

The first firefighting equipment in Jonesboro was a Ford truck secured in the early 1940s by J. A. Suder, a World War II civil defense chairman. The Jonesboro Fire Department was officially organized in 1944. In 1952, Mayor Clarence Lamb and the city council ordered a fire engine. By the time of the 1956 centennial, Chief Clifford Wiggins and 21 volunteers were meeting regularly for training.

John Bell Hutcheson (1860–1938) served as mayor of Jonesboro and solicitor of the city court. He also taught school and edited the town newspaper. After 10 years in Ashburn, Georgia, Hutcheson returned to his law practice in Jonesboro in 1916. Gov. Hugh Dorsey appointed him judge of the Stone Mountain Circuit in 1919. In 1934, Gov. Eugene Talmadge appointed Hutcheson to serve as a justice on the state supreme court.

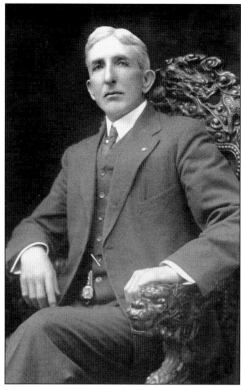

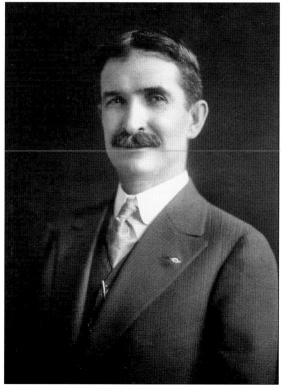

Claude Hill Hutcheson was a prominent businessman and politician in Jonesboro. Gov. J. M. Terrell appointed Hutcheson to serve on his official staff. He served four years as a commissioner of roads and revenue for the state and also served on the state executive committee. Locally Hutcheson served on the county commission, the Jonesboro City Council, and as a school board trustee. He owned and operated the Jonesboro Bagging Company.

Dr. Thomas M. Rivers (1888–1962) was among the first to establish the importance of viruses as a distinct group of infective agents. He was a leader in the development of poliomyelitis vaccines. Rivers served as a director for the Rockefeller Hospital and the Rockefeller Institute for Medical Research. The Legion of Merit was awarded to Rivers in 1945 for his service as officer in command of the U.S. Naval Medical Research during World War II.

Dr. Alfred Blalock (1899–1964) became surgeon-in-chief at John Hopkins Hospital in Baltimore and professor of surgery and chairman of the department at the medical school. During the 1940s, he developed the surgical technique used today to help "blue babies," or infants born with congenital heart defects. He also made fundamental contributions to the physiology of shock.

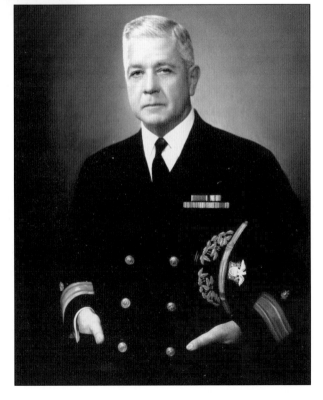

Jonesboro Fire Department volunteer Lamar Wilson is shown practicing methods of fighting fires at one of the weekly practice and training sessions. The photograph below shows the Jonesboro Volunteer Fire Department Building in 1952.

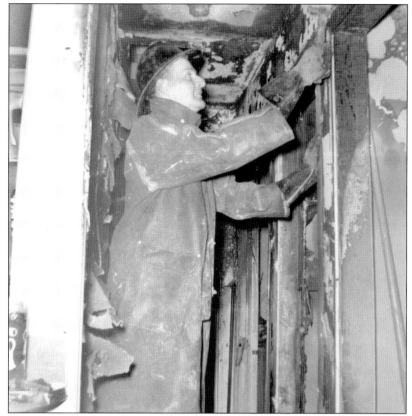

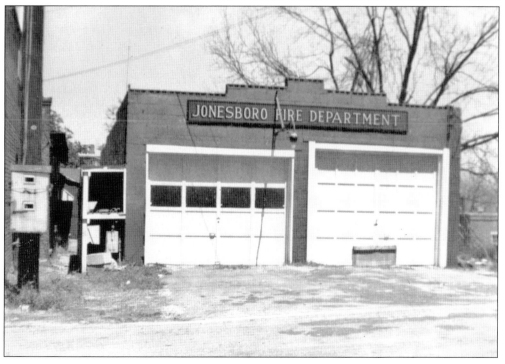

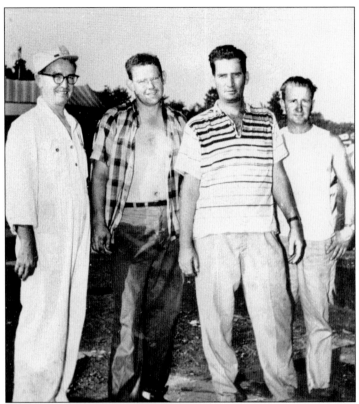

Jonesboro volunteer firemen posed for this photograph after a fire in the early 1950s. Pictured from left to right are Hoke Cartledge, Roger Trammell, Clifford Wiggins, and Jack Scarbrough.

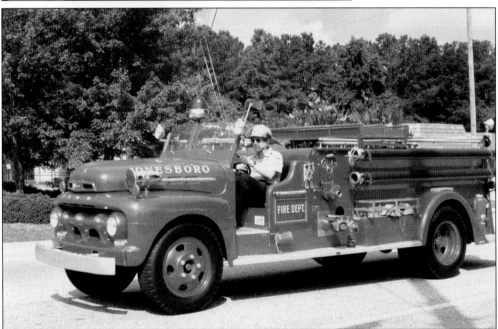

Mayor Clarence Lamb and the Jonesboro City Council purchased this vehicle, driven by Art Metcalf, for the use of the volunteer fire department in 1952. It was the first factory-designed truck purchased for use in Jonesboro.

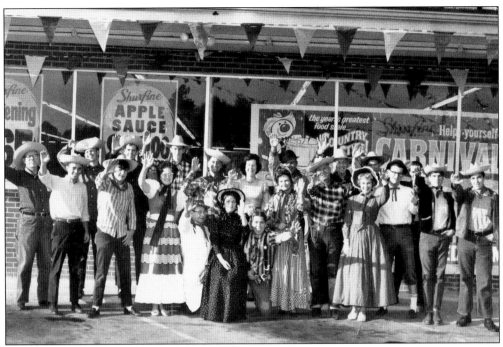

In the mid-1950s, Jonesboro celebrated the grand opening of a Food Town store operated by the Kent family. This was the first large grocery in the city. It was located on North Main Street next door to the Jonesboro Post Office. The building was recently demolished by the city.

John Franklin Oakes was 23 years old when this photograph was made, before his wedding to Vernie Ione Parker. Oakes managed Mundy's Mill before entering the grocery business. He operated a store at 116 North Main Street from 1952 to 1958.

Frank C. Brown Sr. operated a store near Mundy's Mill that sold the only gasoline between Fayetteville and Jonesboro. He was married to Winnie Medlock, and they lived on Tara Road. In 1940, they moved into the old church parsonage on College Street.

CARD MUST BE PRESENTED AT EACH PURCHASE

THE PURE OIL COMPANY

AFFILIATED AND SUBSIDIARY MARKETING COMPANIES

CREDIT CARD

PURE

Issued by WOFFORD OIL COMPANY, Atlanta, Ga.

Mr. C. H. Hutcheson,

Jonesboro, Ga.

Void After

JAN. 15, 1937

SHOW THIS SYMBOL AND MATURITY DATE ON CHARGE TICKET **No. SH 57001**

Customer's Signature.............................

(Over)

The Pure Oil Company issued this credit card to Claude Hutcheson in 1936. Hutcheson was a partner with William V. Whaley in automobile dealerships—originally Ford and then Chevrolet.

Four

CHURCHES

In January 1825, the Flint River Baptist Church became the first religious organization in Jonesboro. The first pastor, the Reverend William M. Moseley, led 14 followers in 1825. The original log church was located at the site of Hynds Spring. The congregation became known as First Baptist Church after it relocated to Church Street in 1850.

The Methodist Episcopal congregation formed in 1845 with eight charter members. Prior to the Civil War, it was known as the Methodist Episcopal Church South and later the United Methodist Church. Originally located on Old Stockbridge Road, the church relocated to a frame building on College Street and later to Main Street, where they built a beautiful sanctuary in 1905.

In 1879, Presbyterians who had been attending services at Philadelphia Church in Forest Park established their own Jonesboro congregation. The 36 charter members worshipped in the former Methodist building on Stockbridge Street. In 1904, the church and the Masons purchased the old Clayton County Courthouse. The Presbyterians held services on the first floor, and the Masons used the upper level.

Early Catholics, primarily the Hutcheson and Fitzgerald families, traveled to Atlanta for church services. Likewise, the Episcopalians, notably the Warren family and Samuel Jones, attended church in Atlanta until a Jonesboro mission station was established in 1846.

After the war, the African American community established several churches in town. Andrews Chapel United Methodist Episcopal Church began in 1875 in a brush arbor on Spring Street. After worshipping in a frame structure on Kay Street, the congregation moved in 1891 to Watterson Street.

In the post–World War II period, several new congregations were formed in Jonesboro. The Church of God of Prophecy started in 1946. In 1949, the Zion Hill Baptist Church was established.

These churches, no matter what denomination, have provided faith and hope as well as fellowship. The churches have helped individuals, families, and the community in both physical and spiritual ways. They are an essential part of Jonesboro's past and present.

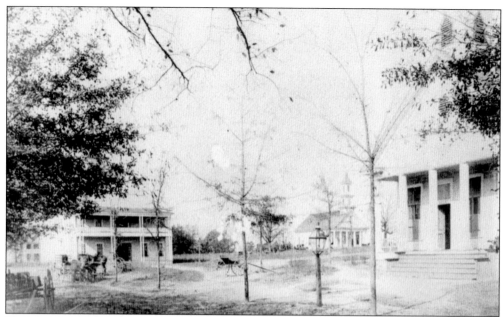

This scene of College Avenue in Jonesboro shows both the educational and religious life of the town. Pictured from left to right are Middle Georgia College, which is located where First Baptist Church stands today; (middle background) the old First Baptist Church; and the Jonesboro Methodist Church, which was dedicated in 1874 and is still in its original location. The Baptist facility was of Greek Revival style with six columns along the front.

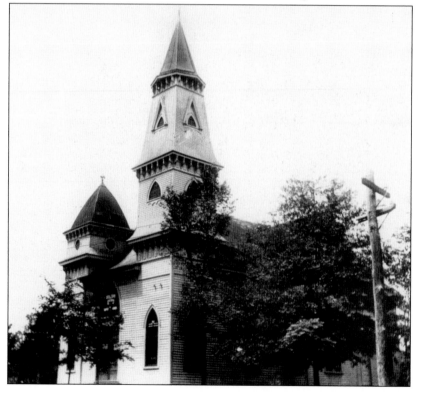

The congregation of First Baptist Jonesboro built this sanctuary in 1892–1893 in the same location as the old building, which had been destroyed by a windstorm. The newer building burned down on January 22, 1922.

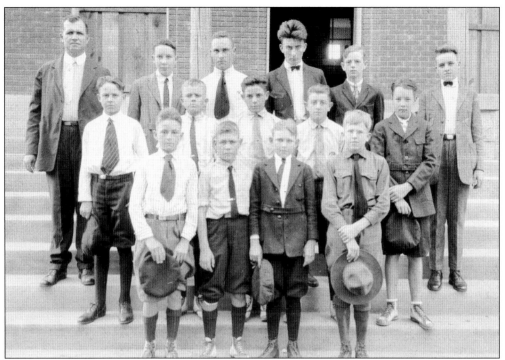

W. V. Whaley Sr. poses with his Sunday school students at First Baptist Church of Jonesboro. Whaley was a longtime deacon of the church.

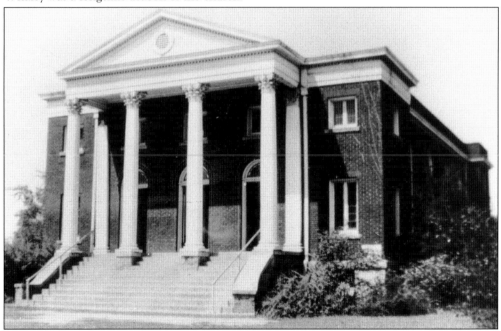

The worship center for First Baptist Church of Jonesboro was built in 1922 after a January fire destroyed the 1892 wooden sanctuary. After losing three buildings to fire and wind, the Baptists built a brick structure. Herbert Massey and J. A. Reiser served as pastors during this project. The building was used until 2000, when it, too, was destroyed by fire.

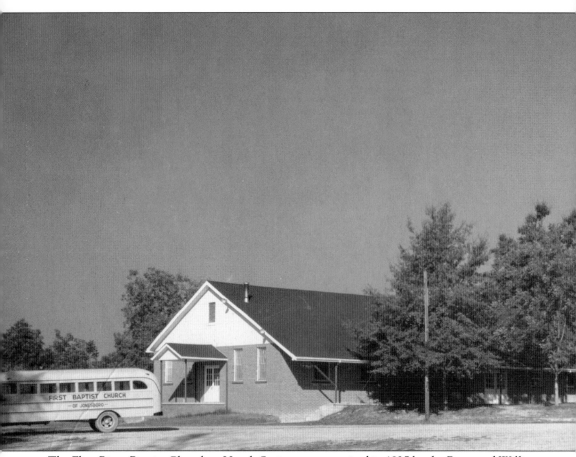

The Flint River Baptist Church at Hynds Spring was organized in 1825 by the Reverend William Moseley. In 1859, it moved into downtown Jonesboro, and in 1868, the church changed its name to the Jonesboro Baptist Church. This photograph shows an early educational building and the side of the 1922 auditorium at the far right. One of the pastors during the early years (1844–1854) was the Reverend Joshua Callaway. It was reported that Callaway had baptized more than 4,000

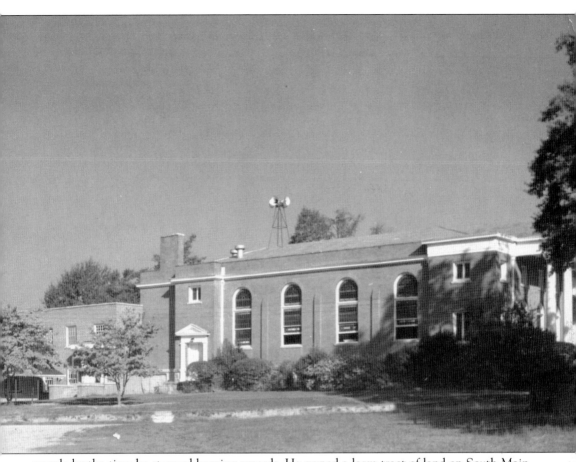

people by the time he stopped keeping records. He owned a large tract of land on South Main Street, where he is buried. One of Callaway's daughters married the Reverend Aaron Cloud. Cloud led the church from 1860 to 1886 and again in 1889. He owned the *Jonesboro News*, the Jonesboro Hotel, farms, and other properties.

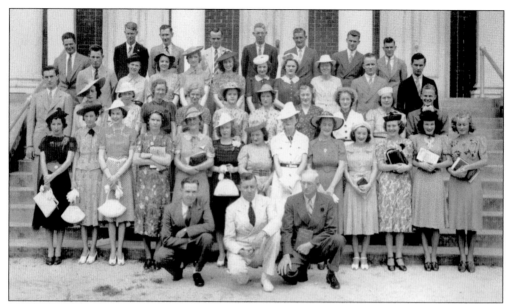

Members of First Baptist Church of Jonesboro gathered in front of the 1922 sanctuary for a group photograph. They are, from left to right, as follows: (first row) B. Turner, C. C. Buckelew, and Burt Cauthan; (second row) Alma Allen Burks, Sue Hall, Lucille H. Whaley, Alice Roberts, unidentified, E. K. M. Waddy, E. White, Mary Lynn Murphy, Marion Brown, Gladys Camp Landers, Sybil Wynn Mundy, Molly Puckett, and June White; (third row) Bill Thompson, Mattie Ruth Tillman, Mildred Waddy, Bella Gazaway, ? Gazaway, ? Godfrey, Francis White, unidentified, Mae White, Nellie Walker, and Ed Brown; (fourth row) Jack Mundy, Bill Mundy, Ethene Wallace, Mary Ruth S. Wallace, Lois Wallace, Carolyn Woodward, Marie White, Blanche Hooks Ledford, Frances Waddy, Bill Whaley, and Elbert Smith; (fifth row) Raymond White, O. A. Harris, Gene Adamson, Jewell Gazaway, Buran Morris, Wilbur Whaley, and George "Mutt" Waddy.

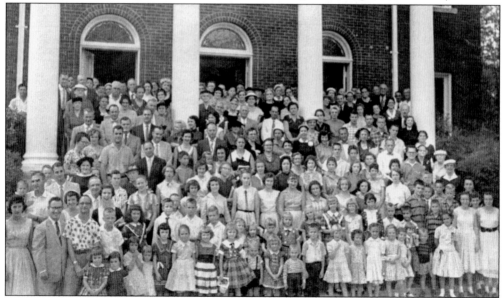

The morning congregation at the First Baptist Church of Jonesboro posed for this group photograph in the late 1950s.

Reba Stewart (1889–1973) left her
Jonesboro home in 1919 to serve as
a Southern Baptist missionary in
China for more than 30 years. She was
interned by the Japanese in 1941 and
was later released to U.S. forces in a
prisoner exchange. Stewart returned to
the United States in 1942.

John Pearley Oakes (1917–1965)
was a Baptist minister who served
churches primarily in Alabama. This
photograph was taken in October
1943. Oakes was the son of John F.
Oaks, a Jonesboro grocer, and his
wife, Vernie.

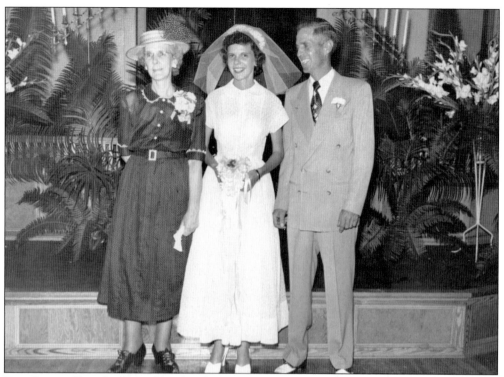

First Baptist Church of Jonesboro has been the scene of many weddings. In 1951, Grace Purdy married Jimmy Oliver in the 1922 sanctuary. The bride posed with her parents, Ellie and Ed Purdy, following the ceremony.

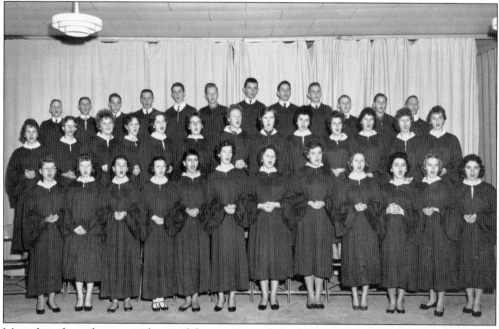

Music has always been a vital part of the programs of the First Baptist Church of Jonesboro. This photograph of the youth choir was taken in the mid-1950s.

The Jonesboro United Methodist Church, founded in 1845, held its early services in the homes of its members. The first official church building was on Stockbridge Street. The congregation occupied the building on Church Street (above) from 1874 to 1905. The building featured two front doors, one for the ladies and one for the men. It was torn down and replaced by a church parking lot. The sanctuary pictured below was built in 1905 on Main Street between Church and College Streets. This view is from Church Street. The 1914 building with the front towers was replaced in 1966 with the building that still stands on Main Street.

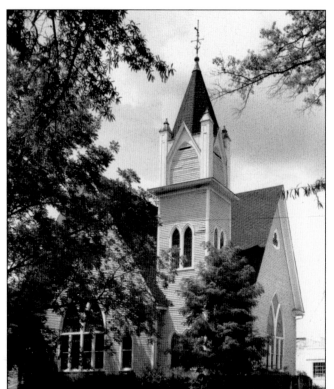

The 1905 sanctuary of the Jonesboro United Methodist Church was built under the leadership of the Reverend J. E. England. The gray, white-frame building with front towers had a semicircular portion at the back that had several small rooms for Sunday school classes. It featured two towers. Both the bell in the tall tower and an elegant chandelier proved too heavy for the building and had to later be removed.

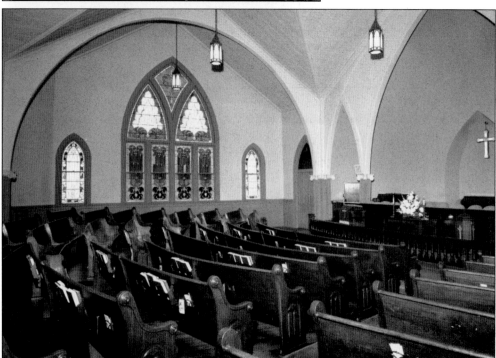

This interior view of the 1905 Methodist auditorium shows the beautiful stained-glass, arched windows. The seating arrangement was wide, rather than the usual long, narrow pattern.

Amanda Lee Burnham and Carol Friddell Roberts leave Jonesboro Methodist Church following their wedding in August 1954. Roberts operated Roberts TV Service in Jonesboro for many years. Amanda was a charter member of Historical Jonesboro. She has been active in the preservation and restoration of buildings that have been moved to the organization's property off Jodeco Road.

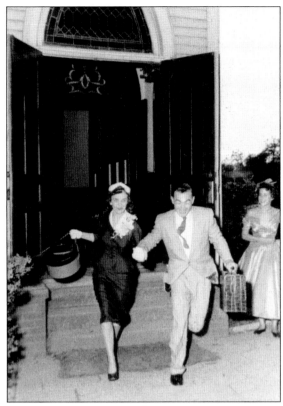

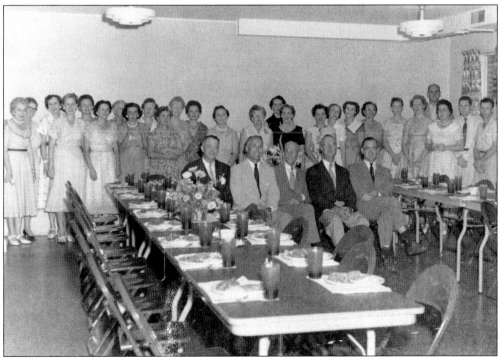

The members of Jonesboro United Methodist Church gather for a fellowship meal.

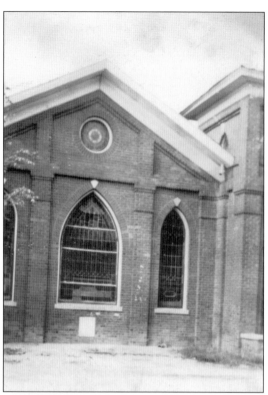

Shiloh Baptist Church met in this sanctuary until it was destroyed by fire.

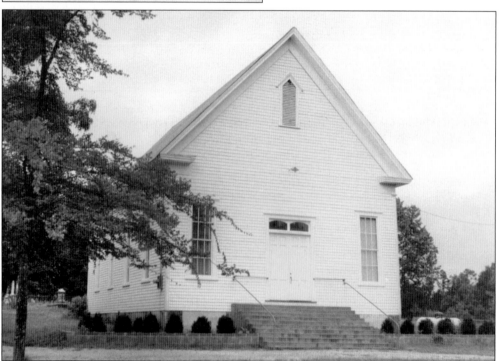

Noah's Ark Methodist Church, on the outskirts of Jonesboro, worships in this 1880 Gothic Revival building.

Five

EDUCATION AND CHILDREN

Education in the early days was reserved for those who could afford to pay teachers, who would establish small private schools or academies. In 1823, a state charter was granted for the Leakesville Academy. By 1849, the town had three schools.

In 1858, Allen D. Candler (who later became governor of Georgia) opened Clayton High School with about 60 students. His sister, Maggie, taught at the school when Candler went to war. The school closed as the Yankees drew near. Attempts by Candler to reestablish the school in 1867 failed.

By 1871, the town had established two schools—one black and one white.

In 1879, Middle Georgia College was established on property purchased from the Baptist Church for $5. George Cleveland Looney and Carrie Camp Crawley served as administrators of the private institution. The primary through collegiate levels at the school corresponded to what are now elementary through junior-college levels. Tuition averaged $5 a month. In 1890, Looney left Jonesboro, and Crawley continued for a time.

From 1883 to 1885, due to a dispute over the cost of tuition, school was also conducted in the Presbyterian church building on Stockbridge Street.

The school became a public school called Jonesboro High School in 1893. A nine-member board of education was authorized. After two buildings and two fires, the school eventually moved to its present location in 1916. Fire struck this building a year later, and classes were held in the county courthouse for 18 months.

Flora Blalock became principal in 1927 and oversaw the consolidation of the school with those from local areas such as Noah's Ark, Philadelphia, and Hebron. Under the leadership of J. E. Edmonds, beginning in 1944, the school added a band and football, baseball, tennis, and track programs. It remains the only high school in the city.

Most of the children featured in this chapter were educated in the various schools mentioned above.

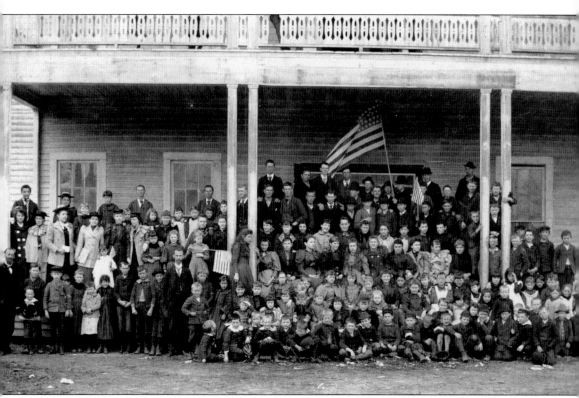

The students and faculty of Middle Georgia College gathered in front of the school building for this picture taken about 1892. Middle Georgia College opened its doors in 1879 on land purchased from First Baptist Church for $5. This original wooden structure featured two levels with a two-tiered porch. It was destroyed by fire sometime around 1900. The school was located on the site of First Baptist Church of Jonesboro's chapel building. The majority of the students were in the school's primary department, which was comparable to present-day elementary and junior high schools. Studies focused on the classics, humanities, literature, mathematics, natural science, music, and art.

The Looney/Hanes/Smith House was built for Prof. George Looney, the president of Middle Georgia College. The green gabled house located at 139 College Street stood directly across from the college. Looney and his family boarded out-of-town students in this 10-room structure. Looney had purchased the property from Elisha Hanes, who bought it back for his son J. Carlton Hanes. Hanes's daughter, Edith Hanes Smith, and her family resided there for many years. It is now the Jonesboro Greenhouse.

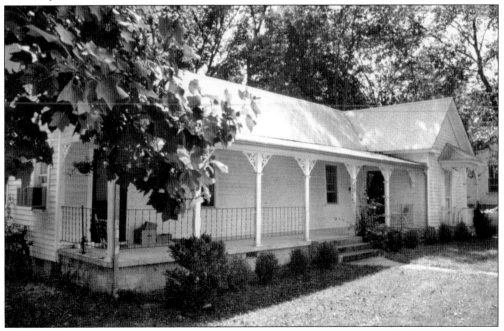

The Middle Georgia Faculty House was constructed in 1880.

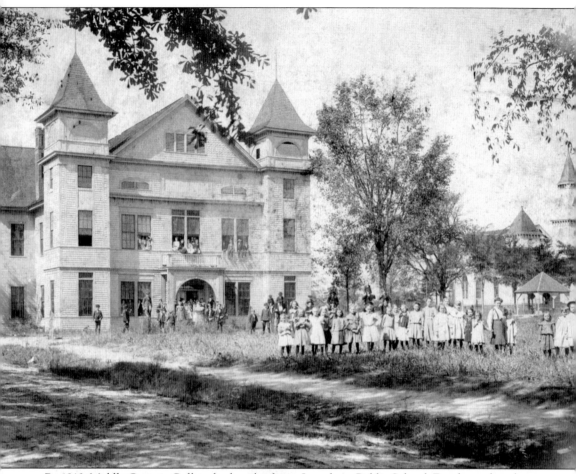

By 1910, Middle Georgia College had evolved into Jonesboro Public School. Faculty and students gathered for this photograph in front of the second building, which featured the towers at the front corners. This structure burned down several years later. First Baptist Church of Jonesboro is visible on the far right.

The Jonesboro District High School class of 1914 gathered for a photograph following their graduating exercises on May 29, 1914. The program included music, recitations, and a playlet entitled "A Bundle of Matches" presented by the graduates.

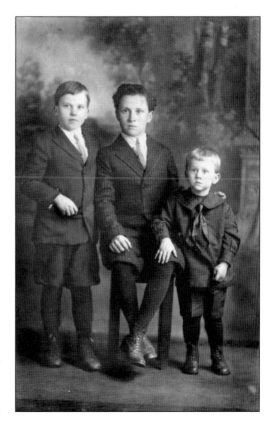

Pictured from left to right, Morris Whaley, Marion Whaley, and Wilbur Whaley, the three sons of Andrew Jackson Whaley and Nellie Camp Whaley, posed for this photograph in 1919. The family lived on Fayetteville Road on property that is now the Whaley's Lake Subdivision. Wilbur was mayor of Jonesboro from 1986 to 1990. He owned Whaley Home and Auto Supply for 30 years. The company was located next door to the Methodist church at the corner of Main and Church Streets. Morris worked at the Ford Plant, and Marion was in real estate.

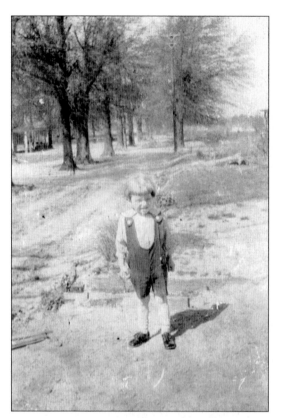

Robert McMullen is standing in the middle of South Avenue (facing west) in this photograph taken about 1927. Robert, born in March 1924, was the son of William Eugene and Martha Eugenia McClendon McMullen.

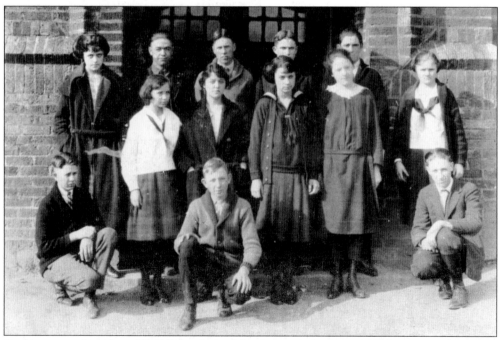

Sophomores at Jonesboro High School posed for this group picture in 1923.

A young Claude Whaley enjoys a telephone conversation. Always the salesman, Claude Whaley returned from World War II, worked at Universal Motors, and owned his own automobile dealership, Whaley-Mitchell Volkswagen in Forest Park, Georgia.

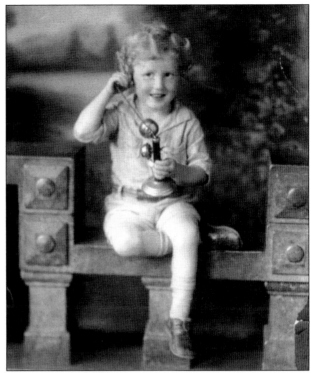

Eula Duffee operated the Kiddie Kindergarten Kollege in her home for many years. Her class of 1926 is shown here on the steps of First Baptist Church.

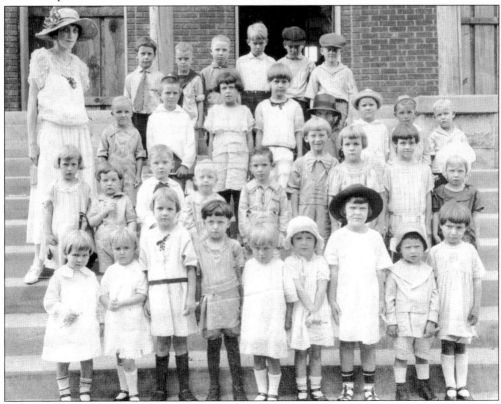

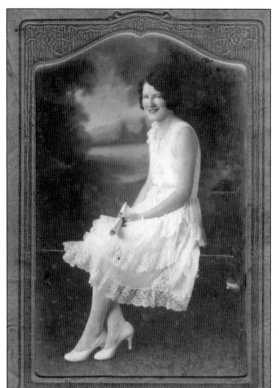

Katherine Idell Hightower's senior picture from 1928 reflects the current fashion of the day. After graduation, Hightower attended Georgia State College for Women in Milledgeville, Georgia.

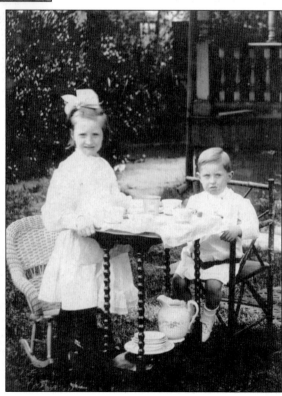

Clara Louise Waldrop and Erle Houston Waldrop enjoy a tea party at the old Waldrop/Warren House in 1909.

Mary Louise Whaley (Carmack) and her sister Sara Whaley (Reeves Whitlock) sat for this formal photograph around 1916 (right). They are dressed in the typical "Sunday dress" of the period. Dressed in classic 1940s clothing, cousins Cleonell Carmack (Hudson) and James Reeves pose for the camera (below).

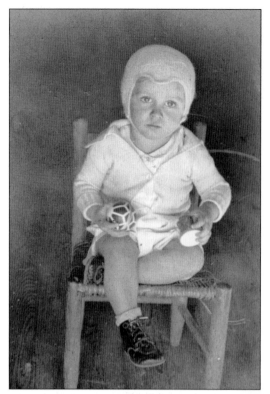

Ronald "Ron" Coleman Brown was only one year old in 1934 when an itinerant photographer came to his family's Jonesboro home and offered to take some pictures. Brown's mom grabbed a chair and had her youngest son pose (left). In 1940, the city experienced an unusually heavy snowstorm. Sister Macie (right) and brothers Ron (center) and Frank Brown walked across the railroad tracks from their house to pick up the mail. A man driving by in a truck took this picture and gave it to their mother. Ron Brown recalls that it was so cold in the winter of 1940 that all the food his mother had canned in the fall was frozen and had to be discarded.

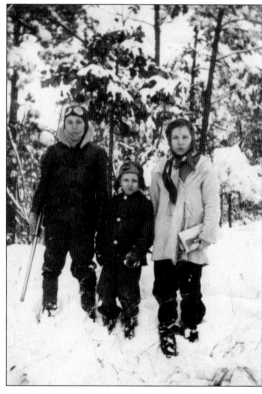

Cleonell Carmack Hudson, age three, sits on her Grandpa Brown's side porch at 201 South Main Street. It was 1936, and Jonesboro was in the throes of the Great Depression.

Roger Oakes, age two, plays with his pet chicken. This 1938 photograph was made on Stockbridge Road in the area of the former Rock Hill Lake.

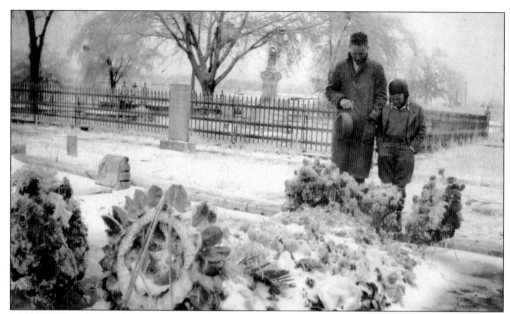

Children face the harsh realities of death in this photograph made on December 15, 1932. William Venable Whaley Jr., age 15, and Claude Whaley, age 8, are shown at the graveside of their mother, Nellie Brown Whaley, in the Jonesboro City Cemetery. Before the death of his wife, William Venable Whaley Sr. had buried four infant sons. Both brothers served in World War II and later owned automobile dealerships.

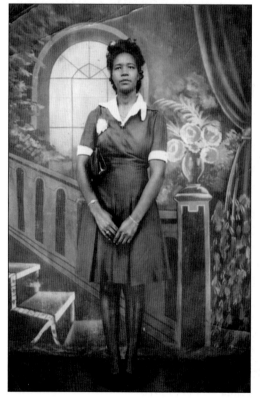

Jessie Freeman was 16 years old in 1939 when this photograph was made. African Americans were not permitted to enter professional photography studios to have their pictures made. However, backdrops and props were frequently set up at the outside rear of the shop for this purpose. Churches also "staged" photographs, such as this one of Freeman, during special events. Freeman later attended business college and worked for the federal government.

Louise Whaley Carmack was born in 1907. She married John Daniel Carmack in 1929, after graduating from Bessie Tift College. Louise Carmack taught school for more than 35 years. During a portion of that time, she was chairperson of the English department at Lakeshore High School. She also served as a chairperson of Historical Jonesboro.

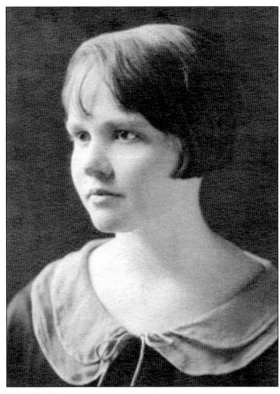

Violet Whaley, one of the first female school superintendents in Georgia, is pictured with her husband, W. V. Whaley Sr. Violet was the Rockdale County School superintendent from 1925 to 1928.

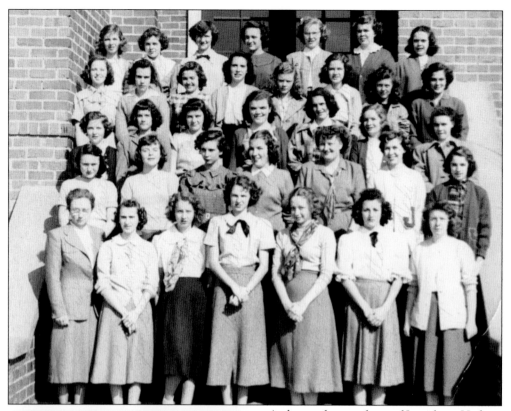

A class gathers in front of Jonesboro High School for a photograph (date unknown).

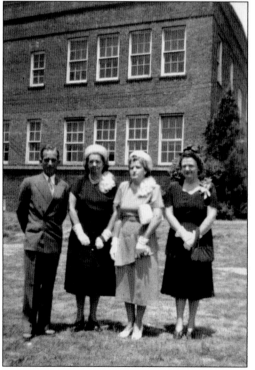

Many outstanding educators have served as faculty and staff at Jonesboro High School over the years. In 1948, some of them posed in front of the school building. They are, from left to right, Principal J. E. Edmonds, Edith Smith, Janette Lamb, and Louise Carmack. Edmonds would later become a Clayton County school superintendent.

Cleonell Carmack Hudson stands in front of the family car at Jonesboro High School in 1949. Hudson's mother was faculty member Louise Carmack. Her father, John Daniel "Tamp" Carmack, taught her how to change tires and spark plugs before allowing her to get a driver's license.

Lillie Aurora Eckman Suder moved to Jonesboro in 1928 with her husband, John A. Suder Sr., and their four children. The Suder family was involved in civic, cultural, educational, and religious activities and received numerous honors. The highlight of Lillie's many tributes was the dedication of the Lillie E. Suder Elementary School by her good friend and the coworker on many of her activities, Supt. J. E. Edmonds.

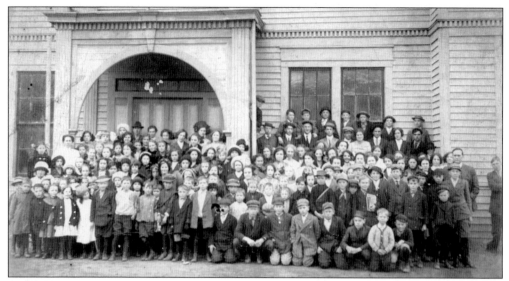

By the time this photograph was made in approximately 1912, the trend away from private to public education had taken hold in Jonesboro. These students were enjoying a "free" education. The Middle Georgia College became a part of the public school system, and shortly after the close of the 19th century, the building became the Jonesboro Public School. This property was used until it was destroyed by fire a few years later. The school was then relocated to Spring Street and later to its present location on Mount Zion Road.

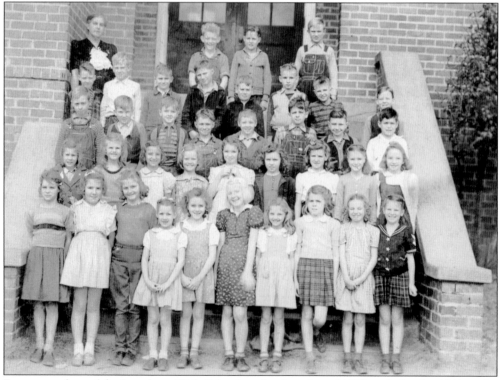

Future members of the Jonesboro High School graduating class of 1950 smile for this 1941 grade-school photograph.

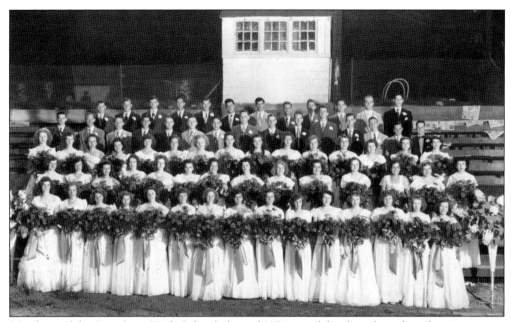

Members of the Jonesboro High School class of 1950 posed for their formal graduation picture (above). The ceremonies took place on the football field (below). All of the girls wore long white gowns and carried bouquets of a dozen red roses. The men wore suits. Caps and gowns were not introduced to the school until years later.

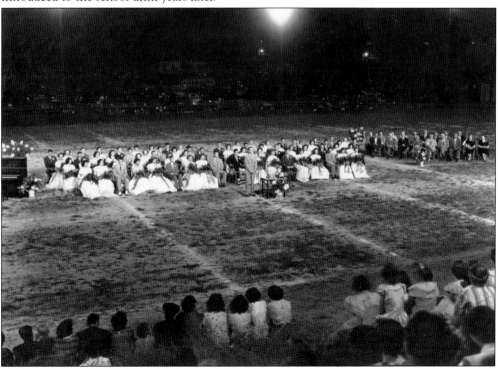

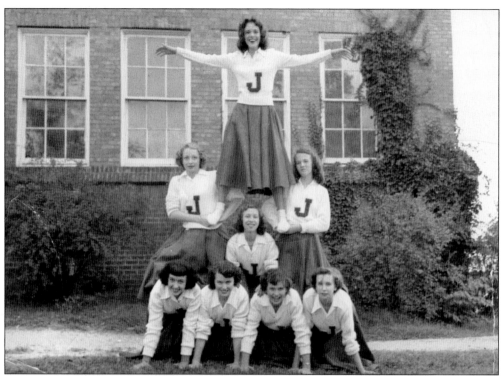

Jonesboro High School cheerleaders show their school spirit in this 1950s photograph.

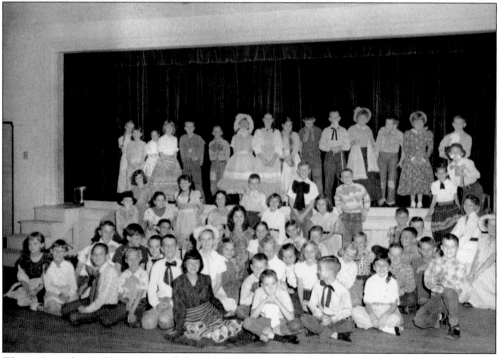

These Jonesboro Elementary School students enjoyed a Pioneer Day program in this 1956 photograph.

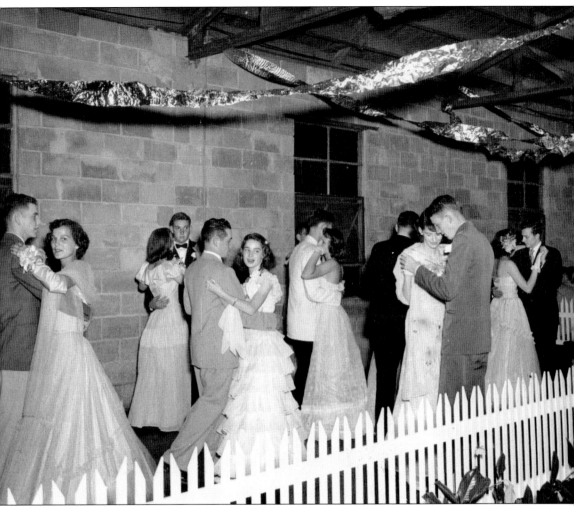

Jonesboro High School juniors and seniors celebrated their 1952 prom in the decorated
school cafeteria.

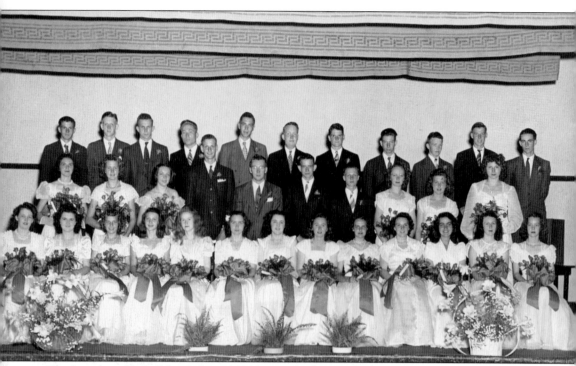

The Jonesboro High School class of 1946 were the first graduates of the post–World War II era.

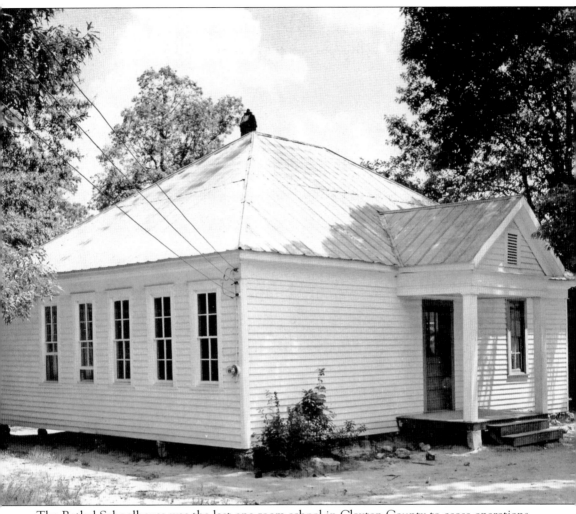

The Bethel Schoolhouse was the last one-room school in Clayton County to cease operations. It was owned by Bethel Baptist Church and given to Historical Jonesboro/Clayton County, Inc., to be moved to Stately Oaks. It has been restored and is used for meetings and social functions. A portion has been furnished as a period schoolhouse.

Jim Huie was a member of the prominent Huie family, which ran a beef-cattle business. Huie was an avid horseman and had taken part in numerous competitions. In 1965, at age 14, he was riding horseback with a classmate, Judy Cash, to Fayetteville. During their ride, Cash's horse became startled and began to run into the path of an oncoming car. Huie quickly steered his horse so he could grab the reins. Unfortunately, both Huie and his horse were struck by the car and killed, but he did succeed in saving Cash. The story was covered in the local media. An anonymous Atlanta citizen contacted the Carnegie Hero Association. Huie was subsequently awarded the Carnegie Hero Medal, which was presented to his parents, Arthur and Lucy Huie.

Six

SOCIAL LIFE

The social life in the early days of Jonesboro centered on the home, school, and church. There is some evidence of the existence of an early tavern but none of a newspaper or a library. As the 1860s approached, travel became easier and the well-to-do families enjoyed "taking the waters" at various resorts, such as in Indian Springs in Flovilla, Georgia; Sulphur Springs in Gainesville, Georgia; and the famous Warm Springs, near Columbus, Georgia. A favorite picnic location was Rock Mountain, which is now known as Stone Mountain.

After the turmoil of the Civil War, the Reconstruction period brought with it a return to the simple, inexpensive pleasures available close to home.

There was general increased prosperity in the 1880s, and Jonesboro residents reveled in an active social scene. A Christmas ball was held on the top floor of the courthouse in 1880.

The availability of alcoholic beverages in 13 establishments ensured that some of the population would engage in rowdy behavior. The barrooms were shut down by 1890, primarily as a result of a one-woman campaign by Lavinia Jane Stewart. The lack of alcohol did not prevent the Stewarts' large Edwardian-style home on College Street from being the site of many large social events and a lodging place for out-of-town guests. Other families with extensive business holdings were equally prominent in social matters. The Blalock, Hightower, Hutcheson, and Harper families all had daughters that were notable beauties of the day. The young ladies enjoyed house parties that lasted for several days, allowing young men to attend some of the evening activities. This chapter captures parts of the rather elegant lifestyle that came to a crashing halt with the Depression and World War II. After the war, Jonesboro experienced many changes, but it retained the social life of a Southern small town.

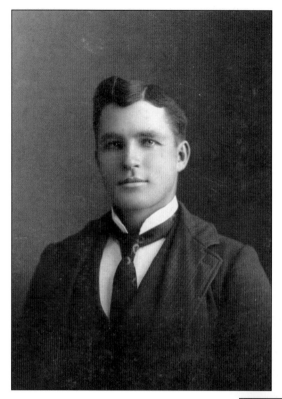

These engagement pictures for John Osgood Hightower and Aileen Louise Waldrop were made in December 1898. They married on June 21 the following year at Kenjocetee (now known as the Warren House), the home of the bride's parents. The local paper waxed eloquent on the event, described as "one of the most beautiful and happy home weddings ever witnessed in Jonesboro." The hallways and rooms were decorated with ferns and flowers. Following the evening ceremony, a wedding supper was served. The *Jonesboro News* reported, "The parents of the groom, Mr. and Mrs. J. O. Hightower, tendered the wedding party dining on yesterday which was marked by much elegance in its arrangements and pleasure for the guests." Aileen Hightower was a charter member of the Frankie Lyle Chapter of the United Daughters of the Confederacy, which established a scholarship fund in her memory.

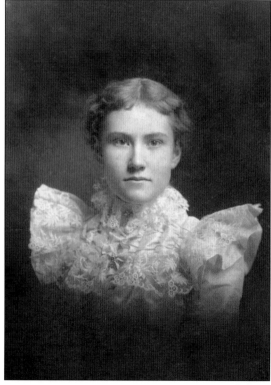

Participating in contests was an exciting event in Jonesboro's early days. Minnie Archer entered a bathing-beauty contest around 1925 and won the title of Most Perfect Figure.

Walter Gray Hightower was a member of Company A, 3rd Georgia Regiment during the Spanish-American War. Upon returning home, Hightower announced his intention to become an actor. Theatrical endeavors were considered immoral by his staunch Methodist family. His father was outraged, but Hightower moved to Houston, Texas, to join a stage company. His life was cut tragically short when he was shot and killed while attempting to assist a friend.

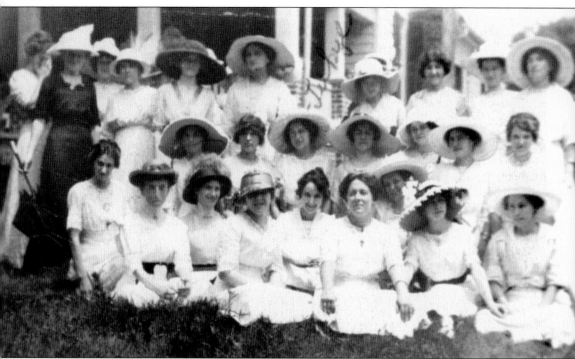

House parties were an exciting pastime for Georgia residents in the early 1900s. Guests, pictured here, came to Jonesboro for a week in 1914 to a party given by Annabelle and Elizabeth Bibb Harper. The girls and their guests spent a week eating watermelon, going on picnics, and attending evening parties that young gentlemen also came to. They would ride the Dummy into Atlanta to see a picture show. The second floor of Evans Mercantile was used for skating parties, where young people sometimes skated to the music of live bands. When the girls reached an appropriate age to consider marriage, their hemlines went from just below the knee down to their ankles. Their hair, normally worn down, was piled on their head and often covered with large picture hats.

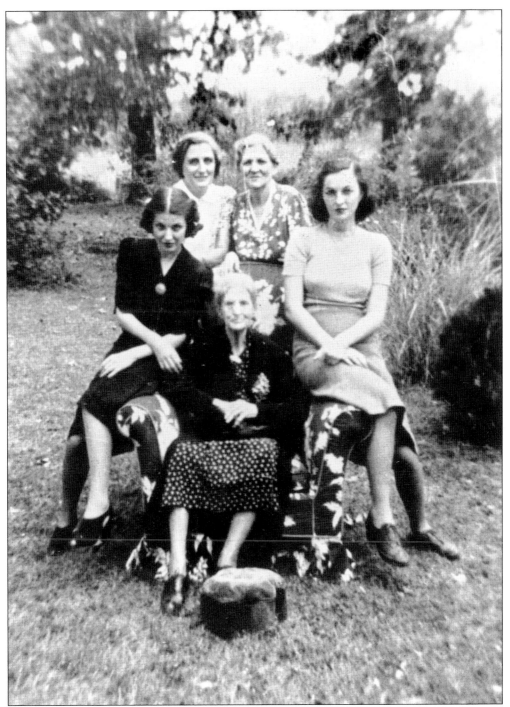

Some of the ladies of the Calvin Orr family pose in a 1940s photo. Clockwise from far left are Blanche Orr, Rosamond Orr, Blanche May Morris (Rosamond's mother), Emily Orr, and Blanche Wright (mother of Blanche May Morris). Blanche and Emily Orr are the daughters of Rosamond and Calvin Orr. Rosamond named their home the Oaks because of the many beautiful oak trees surrounding the house, later changing it to Stately Oaks.

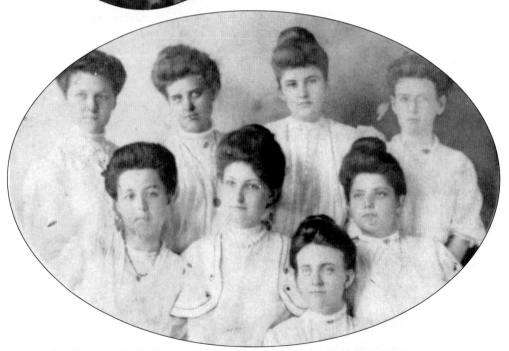

Annabelle Harper was known for hosting wonderful house parties in Jonesboro and was considered a local beauty. The Harper sisters were the talk of the town when they became the first in Jonesboro to "bob" their hair. Annabelle taught school in Jonesboro and later worked in Atlanta for the Internal Revenue Service.

Seen in this photograph of a house party, from left to right, are the following: Radona Ragsdale of Atlanta; Blanche Hawkins of Americus, Georgia; Florence Carmichael of McDonough, Georgia; Lizzie Harper of Jonesboro; Annebelle Harper of Jonesboro; Evelyn Duffey of Morrow, Georgia; Erle Hardman of Atlanta; and Jennie Carmichael of McDonough.

The skating rink on the second floor of Evans Mercantile was a popular spot in Jonesboro, especially when unusual events, such as the masquerade skate party, were held. Lukie Harper, dressed as Nokomis from the poem "The Song of Hiawatha," won the masquerade costume contest around 1914.

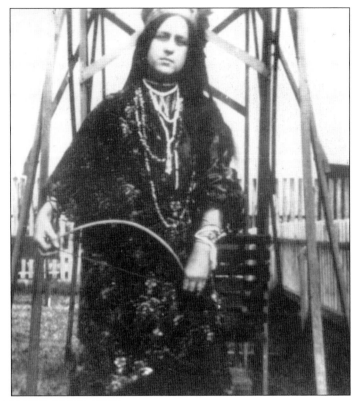

Eula Wilburn and an unidentified friend are shown at the Flint River Bridge. She taught junior high school in Clayton County for 35 years and was elected in 1984 to serve as the first black city councilwoman in Jonesboro. A new alternative school in Jonesboro has been named for Eula Wilburn Pond Perry.

Ida Burnett Wilburn is shown standing in her yard on what is now Wilburn Street, named after her family. She was born in July 1889 and died in April 1984. Wilburn's grandparents were listed in the 1860 Clayton County census as free blacks. Ida and her husband, Mark, were the parents of five boys and three girls.

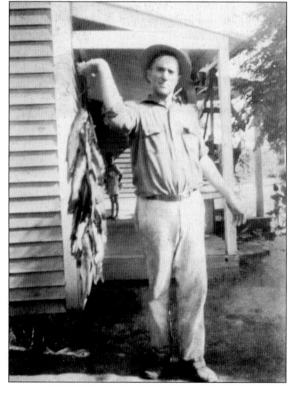

John Strickland displays his good catch after a day of fishing on the Flint River. Fishing was always a popular sport among the men of Jonesboro and often provided the evening meal. Strickland was a disabled veteran who had served in France. He later became a civilian employee at the Atlanta Army Depot.

Many citizens of Jonesboro loved to play golf. Louise Whaley Carmack loved the game and played on her college golf team in 1925.

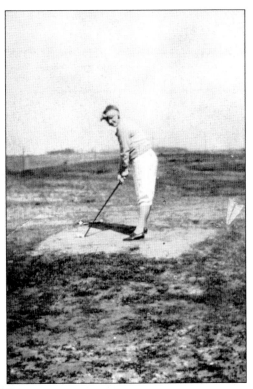

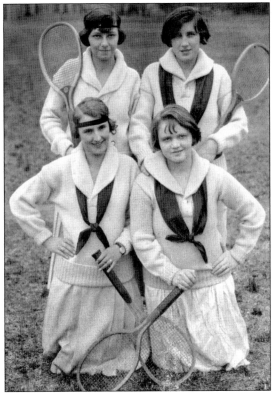

The members of this 1920s Jonesboro High School tennis team are unidentified.

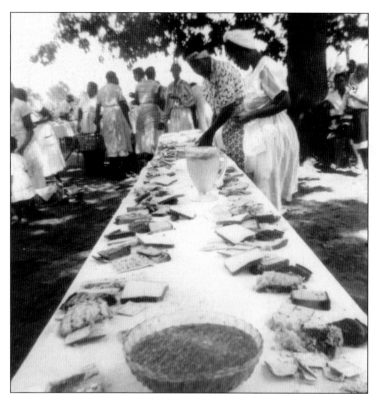

The Freeman family has been gathering in Jonesboro for 100 years to celebrate their homecoming-day festivities. In the early 1950s, members of the family reenacted the meal that was eaten on the first homecoming day. To reenact that meal, family members did not use plates or utensils.

Local entertainers Hoke Cartledge (fiddle) and Ed Conkle (banjo) always brought laughter to their listeners whenever they played their instruments.

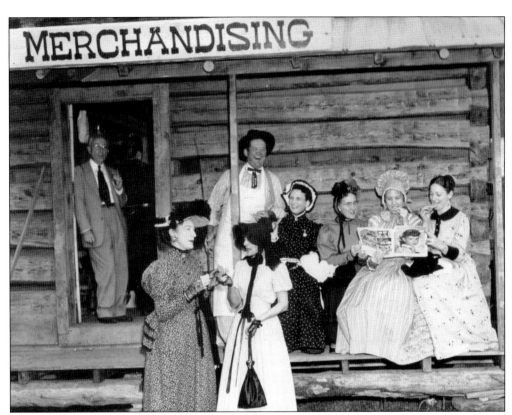

During the 1950s, a summer event was the Southeastern Fair, held at the Lakewood Fairgrounds, near East Point. Fair operators constructed a "Crackertown" with an old country store and post office. Each year, a group of Jonesboro residents dressed in period clothing would work at the fair to add an authentic atmosphere to Crackertown.

Young people in Jonesboro enjoyed the pleasures of a rural life, including horseback riding.

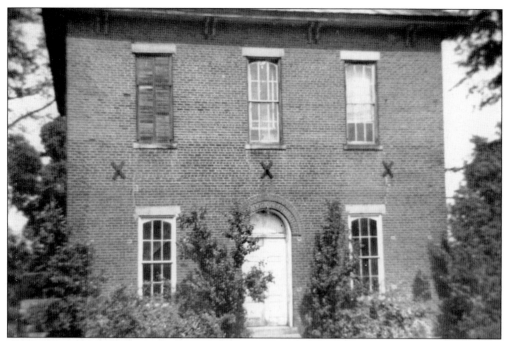

Other than churches, the first organization in town was the Jonesboro Masonic Lodge No. 87, established in 1847. The original 1856 lodge was located near today's train depot. The current hall, pictured here, was purchased in partnership with the Presbyterian Church, which has since built its own worship facility.

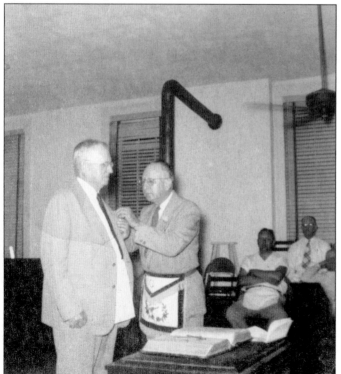

Under the watchful eye of Worshipful Master J. P. Betsill, George Peck presents William Venable Whaley with a pin honoring 50 years of service to Jonesboro's Lodge No. 87, Free and Accepted Masons. The year is 1952, and Whaley would serve the lodge for another 10 years.

The Tara Chapter of the Children of the Confederacy is an auxiliary to the Frankie Lyle Chapter of the United Daughters of the Confederacy. Joan Dickson, daughter of Jonesboro mayor Hugh Dickson, served as Georgia division president. The convention held at the end of her term was hosted by the local chapters. Dickson presented the gavel and presidential pin to incoming president Sandra Lineberger. In the 1950s, the Tara chapter had over 100 members on roll.

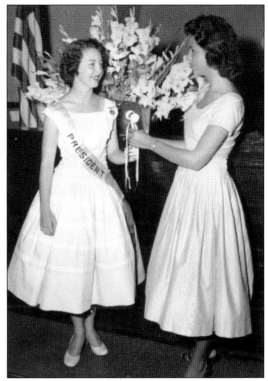

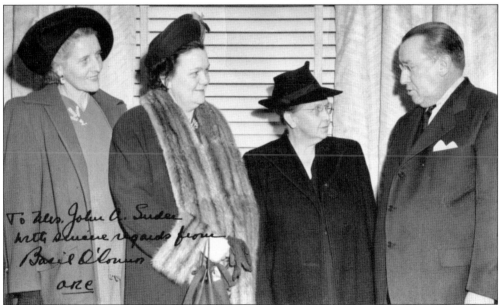

The Clayton County chapter of the American Red Cross was organized in Jonesboro in 1917. During World War I, the chapter members sewed, knitted, and rolled surgical dressings for the troops. During World War II, the local unit became active, and in an 18-month period, 10,000 garments were completed for military use. Lillie Suder became executive director in 1946. Pictured from left to right are Eula Daniel, Francis Burnham, Lillie Suder, and National Red Cross chairman Basil O'Connor.

Aileen Waldrop Hightower and her daughter Annelu Hightower were charter members of the Jonesboro chapter No. 2074 of the United Daughters of the Confederacy. The chapter was organized in 1934 at the home of Frankie Arnold Lyle, for whom the chapter was named in 1953. Aileen was one of the first chapter presidents. The chapter now offers a college scholarship in her memory. Annelu was instrumental in organizing the Tara Chapter of the Children of the Confederacy.

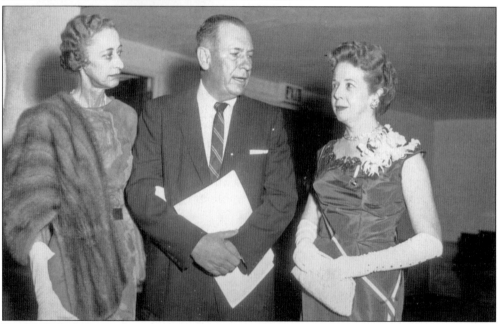

Doris Lyle (right) served as president of the Frankie Lyle Chapter of the United Daughters of the Confederacy for nine years. She also served the Georgia division of the United Daughters of the Confederacy in many capacities, including as president. Lyle is shown here with Gov. and Mrs. Marvin Griffin before the opening evening of the state convention. Governor Griffin delivered the major address. The design and placement of the grave markers at the Patrick R. Cleburne Confederate Cemetery was carried out by Lyle and her husband, Harold.

Seven

WAR AND PEACE

Jonesboro is familiar with war. Shortly after its establishment, the town saw its sons drilling in local militias and then marching off to face the enemy. Four Confederate units were composed mainly of Jonesboro men. The Clayton Dragoons, Company F, 2nd Regiment, Georgia Cavalry were under the leadership of Capt. Francis Thompson Gayden, who was also a doctor. Capt. Chaney A. Dollar commanded the Clayton Invincibles, Company I, 30th Regiment, Infantry. Capt. George Gilmore Crawford led the Clayton Sharpshooters, Company E, 10th Regiment, Infantry. Lt. Col. John Estes was commander of Estes Guards, Company D, 44th Regiment, Infantry.

Old folks, women, and children were left at home to fight a different battle with an invading army. The Battle of Jonesboro, which took place August 31 through September 1, was the decisive battle of the Atlanta campaign. When the Civil War was over, the men came home to desolation and despair. The town was rebuilt, and though never destroyed again by armies marching through, its residents would be touched by wars fought in foreign lands.

The first time after the Civil War that men from the North and South marched side by side was during the Spanish-American War. It is not known exactly how many Jonesboro men served, but mention is made of their service in old county histories.

During World War I and World War II, the majority of men of service age were called to duty unless they had medical or other deferments. Those who could not serve found other ways to support the war effort. The African American community of Jonesboro was represented in the ranks of the military, as evidenced by the photographs in this chapter. Women not only served in the armed forces and as civilian employees for the military, but they worked in places previously unthinkable for ladies.

In peacetime and in war, Jonesboro has not only supplied manpower, but has also been a residence for many who were stationed at nearby military installations, such as the Atlanta Army Depot (Fort Gilliam) and Fort McPherson. Some of them decided to stay and make Jonesboro their home.

It was not possible to include all of the men and women from Jonesboro who served their country during times of war—and in times of peace, as well. It is hoped that those pictured will be viewed as a memorial to all who supported U.S. war efforts.

John Strickland's service resulted in multiple health problems and a shortened life span. Strickland served in the U.S. Army in France. After his discharge, he met a young lady. They began courting, frequently at Mundy's Mill, and soon married. He was a guard at the Atlanta Army Depot and for the county highway department. The disabled veteran could never regain his health, and he died at age 53.

Dorsey Cloud served in the army during World War I. When he returned home on leave, he took his wife, Rose Anderson Freeman Cloud, and young daughter to the Clayton County Fair. This photograph was made on that occasion. After the war, he became a Baptist preacher and evangelist in Georgia and Alabama. Dorsey's grandson, Bobby Bradley, recalls his grandfather driving a "big, long Buick" when he came for family visits.

Lonnie "Buster" Freeman joined the army in 1941 and trained at Fort Benning. This photograph was taken around 1942 or 1943 in Hawaii, where he was stationed. Freeman was a boot driver for the quartermaster of the 24th Infantry Division. He drove landing craft to ships to pick up supplies to be unloaded on the beach. After he left the service in 1946, he was a civilian employee at the Atlanta Army Depot.

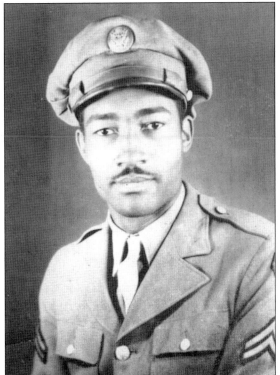

Bobby Freeman served in the European theater (Sicily) during World War II in the Quartermaster Corps of the army. He reported that when his unit was overwhelmed by the Axis forces, he played dead in order to survive. Staff Sergeant Freeman was also responsible for delivering parts for the atomic bomb. After the war, he eventually settled in Baton Rouge. Louisiana, where he worked in the sheriff's department for 20 years.

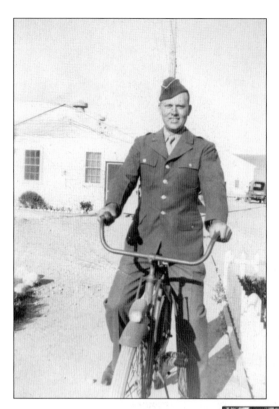

Raymond Cephas Oakes was drafted into the army in 1943 at the height the war. During basic training at Camp Roberts, doctors discovered a medical condition with his feet that caused a medical discharge. Upon reassignment to the home guard, Oakes was promoted to sergeant because he was the only one with military training. His unit was assigned to guard the power plant at High Falls as well as water treatment facilities.

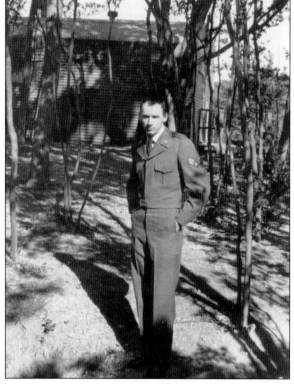

Ronald Brown served in the U.S. Air Force in 1954–1958 and in 1961–1962. This photograph was taken when he was stationed in Japan in 1956. He was assigned to the headquarters staff and taught English. Brown attained the rank of staff sergeant. Brown and his three brothers—Joseph, Frank, and Richard—all received Crosses of Military Service from the Frankie Lyle Chapter of the United Daughters of the Confederacy in appreciation of their military service.

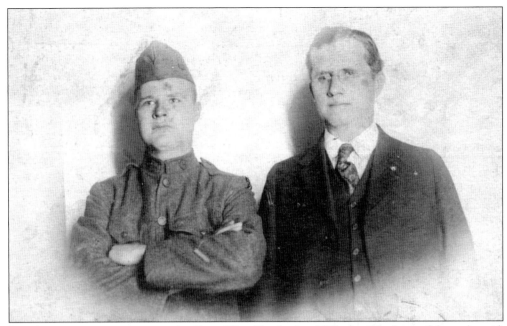

Jonesboro sent its young men to the Great War. Charles Loyd Whaley II looks confident of a swift Allied victory as he poses with his older brother, Jonesboro merchant William Venable Whaley Sr. Charles survived the war and ran a dress shop on Peachtree Street.

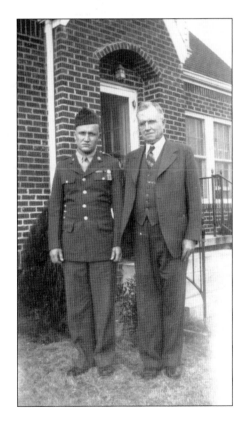

Once again, Jonesboro sent its young men to war. This time it was World War II. William Venable Whaley Sr. stands in the front yard of his Spring Street home with his oldest son, W. V. Whaley Jr. Like his uncle Charlie, Bill Whaley survived war and returned to Jonesboro as a merchant.

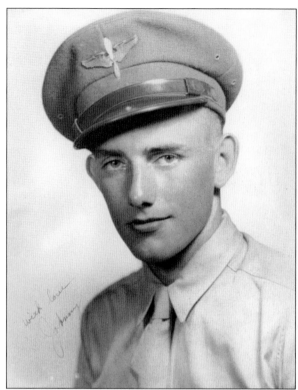

Johnny Suder enlisted in the U.S. Air Force in August 1943 and received his training in Miami, Florida, and Amherst, Massachusetts. He became a navigator. After receiving his "wings," he was stationed in San Marcus, Texas. After the war, Suder attended Georgia Tech, where he earned degrees in aeronautical administration and business administration. He was employed at Lockheed Martin in Marietta, Georgia.

Men were not the only ones to serve their country. Women filled positions left vacant by the soldiers or to free the military from "desk duty." Grace Allene Suder was a clerk at Lawson General Hospital in Atlanta from 1942 to 1944. After she married in January 1944, Suder accompanied her husband to bases in Bainbridge, Georgia, and Jefferson City, Missouri. Grace came home when her husband was ordered overseas.

Eight

THE BOOK AND
THE BATTLE

The people of Jonesboro wanted to tie the town's fate to culture and education. But Jonesboro is a railroad town, and its prosperity was tied to the tracks that ran through its heart. When the railroad prospered, the town grew, and farmers from miles around came into town to stack their cotton beside the tracks, where it waited for the next train. When the agricultural society became a bedroom community for those who worked in the "big city," the railroad was their transportation to and from Atlanta.

When the Civil War came, the tracks were burned, and so was most of Jonesboro. According to the *New York Tribune* of September 1, 1864, more than two-thirds of the buildings were burned, either before or during the two days of battle. What was not burned was riddled by bullets and cannon shells.

Jonesboro's brave men had marched off to war, then came back to town to defend their home, only to march back out again in the heat of the battle, trusting the fate of the town to their beloved comrades. Seasoned soldiers—well trained, battle weary, yet savvy—on both sides understood the importance of the Battle of Jonesboro. Here they would decide the fate of the railroad, the presidency, and ultimately the war and the Union. In two days of what was described as some of the hardest and bloodiest fighting of the war, both sides fought dearly for their cause.

Years later, a young girl named Margaret Mitchell would sit with her family, old soldiers, and the once embattled townspeople to listen to their stories of the war. When she became older, she would forever link Jonesboro to a book about those long-ago days called *Gone with the Wind*.

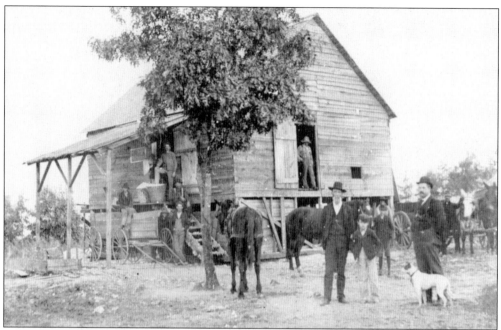

Jonesboro began as an early settlement known as Leaksville, the first community to be populated on the upland east of the Flint River. The majority of citizens were small, independent farmers who had moved into Georgia from the Carolinas, Virginia, and farther north after the Treaty of Indian Springs. Energetic, industrious, and proud, they quickly set up homes, farms, and businesses.

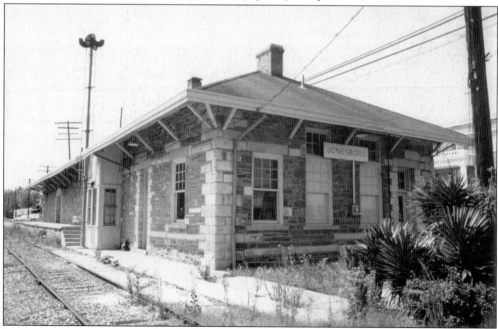

The railroad brought a new life and importance to Jonesboro, as the surrounding farmers needed it to get their cotton to market. But the railroad also brought destruction. When war came to Jonesboro, the defenders knew the southern rails were the last vital supply line to Atlanta. The Union soldiers were determined to remove this link to seal the fate of Atlanta and the Confederacy.

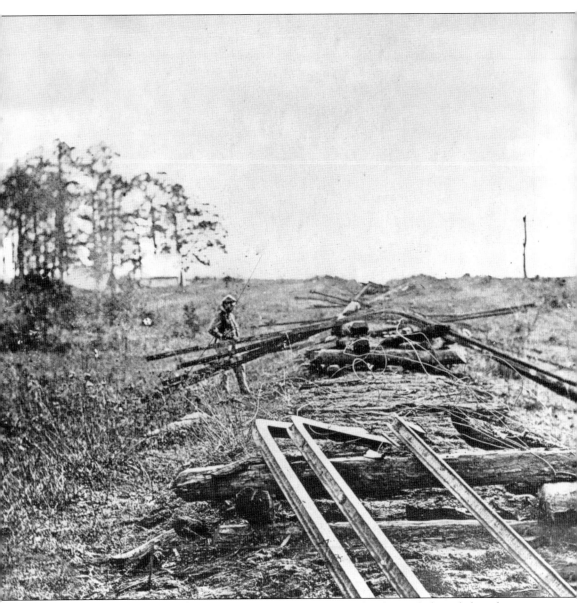

The ravages of war left much of Jonesboro a desolate wasteland. It is believed that this rare photograph was taken north of the original depot across from the Warren House. In the foreground are several "Sherman's Bow Ties." In order to keep Confederate loyalists from reconstructing the railroad, huge bonfires were built to heat the rails until they were red hot. Horses were used to bend the rails around stumps, some making a complete loop. As the Union army prepared to leave Jonesboro, many of the rails were simply bent into an "L" shape. Sherman had sent Maj. Gen. Judson Kilpatrick and 2,500 soldiers to destroy the rails in Jonesboro on August 18, 1964. Kilpatrick quickly dispatched Jonesboro's defenders, tore up the rails, and then burned the depot, post office, and cotton sheds. By August 23, trains were rolling again. On August 31 and September 1, the tracks were destroyed.

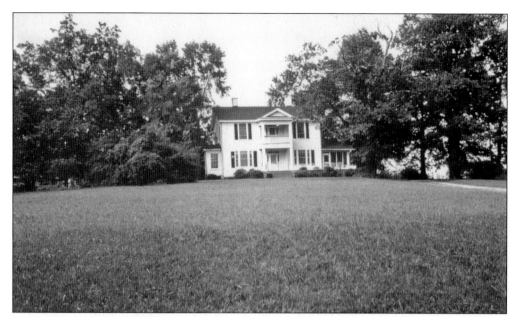

Much of the fighting of September 1, 1864, occurred near and around this house, which sustained heavy damage and still bears some of the scars of war. One story is told of the owner running out to ask the soldiers to move their aim after a cannonball tore through the wall and the headboard of his bed. The house was used as a field hospital and as headquarters for the 52nd Illinois Regiment.

Dr. F. T. Gayden, a trustee of the First Baptist Church, built the first brick house in Jonesboro, made with walls 10 inches thick. Gayden was a captain in Gen. Joseph Wheeler's Confederate cavalry. Gayden's home was used as a field hospital during the battle, and he convinced many of his neighbors to do the same, thereby saving their homes from destruction. The house is under restoration and slated to become a medical museum.

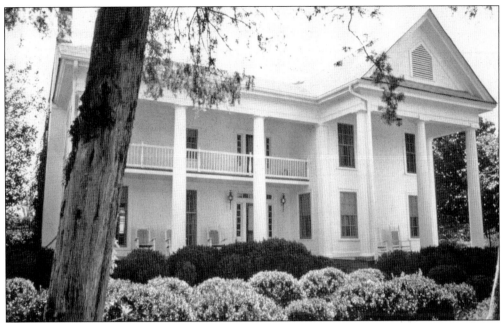

Many battle stories have been circulated about this old home outside of Jonesboro, which now belongs to Betty Talmadge. A Yankee soldier is said to have been shot in the yard. The columns were added just before the war and are said to have been filled with grain, so the grain would not be found and taken by the soldiers. During its restoration, bullets were found in the walls by the family.

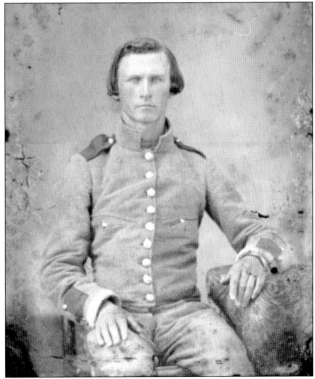

Many local families claim long pedigrees, some dating back to Jamestown. These were people whose progenitors had served through the Revolutionary War, the War of 1812, and many skirmishes. Enlisting for military service was not only an honor, but also a way of life. William Thomas Roberts (1825–1861), one of the first Jonesboro residents to serve in the Confederate army, enlisted in Company E, 10th Regiment, Georgia Volunteer Infantry, Army of Northern Virginia, or the Clayton Sharpshooters.

Most of the residents of Jonesboro fled town when they heard that soldiers were coming their way. Wherever the fighting went, the officers would take over homes or offices to use as headquarters and field hospitals, while other soldiers would take the food and livestock from the homes of residents. When they were caught by their officers, the soldiers were often made to pay the residents. This was the first time many saw a "greenback" dollar.

The railroads were the major supply lines for the armies, especially as they moved farther away from home. Both sides would set up a supply camp along the rail lines and establish a command post, which allowed for faster dispatch of orders, troops, and supplies as needed on the front. Without the railroads, transportation through the woods and over rough, rain-soaked roads was treacherous, slow, and could be the cause of losing a battle.

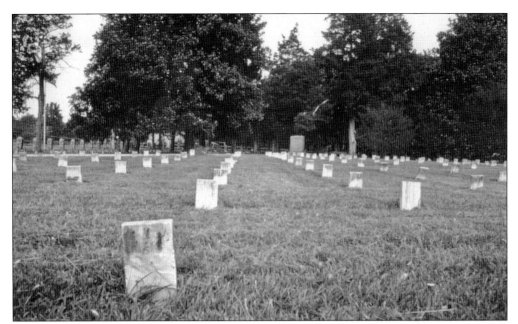

The Patrick R. Cleburne Confederate Cemetery is the final resting place of between 600 and 1,000 Confederate soldiers who fell at the Battle of Jonesboro August 31–September 1, 1864, along with several who died in local hospitals. The 712 headstones are laid out in the pattern of the St. Andrews Cross, although the bodies are actually buried in two long trenches. Most were originally buried where they died but reburied on this plot with those from the hospitals.

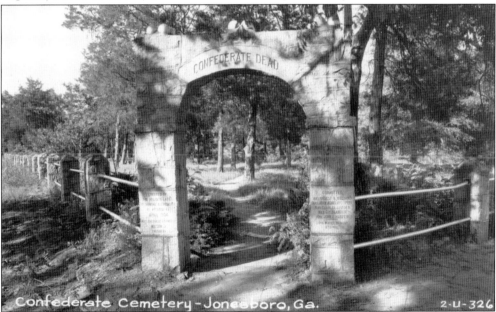

A Ladies Memorial Association was formed and worked to procure funding to move the dead to a common site. In 1934, a granite monument, stone-and-metal fence, and beautiful stone archway were added. The ceremonies were attended by the last two survivors of the battle. For many years, the schoolchildren observed Confederate memorial day by marching in a procession from school to the cemeteries, their arms filled with floral bouquets to decorate the graves.

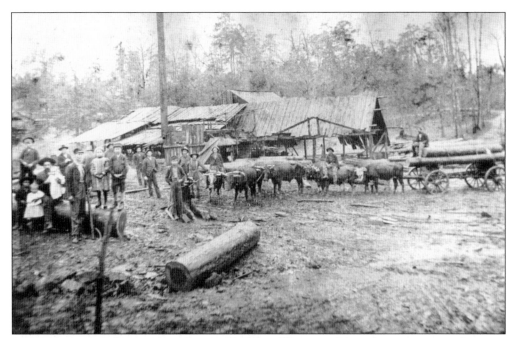

After the war, Jonesboro citizens began rebuilding. The area did not have extremes of poverty or wealth, so the people recovered quickly and returned to their industrious ways. Most of the residents were small, independent farmers, but many doubled in the practice of other businesses, such as running sawmills and cotton gins, carpentry, and blacksmithing.

Mundy's Mill was owned and operated by one of Jonesboro's pioneering families and represents an occupation that flourished in the area due to the many farms and the small streams, suitable for damming. This particular mill was said to be the inspiration for the mill shown in one scene of the movie *Gone with the Wind*. The book and the movie focused on the Jonesboro area and the Battle of Atlanta.

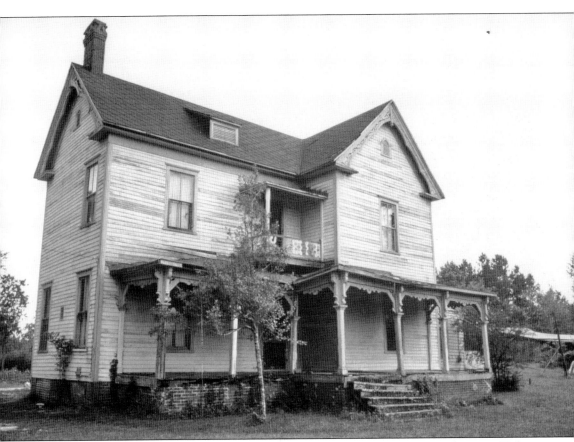

The Fitzgerald plantation house was the home of Margaret Mitchell's great-grandparents, Philip and Eleanor McGhan Fitzgerald, who referred to it as the "Rural Home." Her mother, May Belle Stephens-Mitchell, frequently took Margaret during her summer vacations to visit her great-aunts, Mary "Mamie" and Sarah "Sis," who still lived in the house. Little Margaret would sit on their laps, listening to their many stories about the war and developing a love for the period and the courage of the people who lived through it. It has been said that Margaret Mitchell herself said that this house was her inspiration for Tara in *Gone with the Wind*. The house was purchased by Betty Talmadge and moved to her farm in Lovejoy, Georgia, where she had planned to restore the home as a possible attraction. Unfortunately, this was never done, and the Rural Home is deteriorating.

Jonesboro was abuzz with excitement on December 11, 1939, when the town had the honor of hosting the first event of the three-day premiere of *Gone with the Wind*. The *Atlanta Constitution* and the Frankie Lyle Chapter of the United Daughters of the Confederacy sponsored a reenactment of the escape by wagon from the burning city of Atlanta and Sherman's army. Local residents Molly Puckett (Scarlett), Ida Louise Huie (Melanie), Leola Lyons (Prissy), Lowell Wooten (Wade Hampton, Scarlett's son in the book), and newborn baby doll Beau departed from the old Union Station in Atlanta and arrived to a welcoming crowd, including Mayor Hugh Dickson.

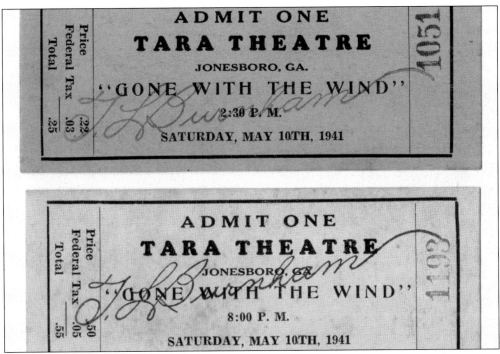

The Tara Theater was owned and operated by Thomas Leon Burnham. He installed the seating for 100 people himself. Capitola flour contained tokens that were worth about a nickel. Mrs. Burnham accepted these as part of the price of a ticket. The Tara was a popular spot for courting. *Gone with the Wind* was the longest-running movie during his ownership, although the movie did not run in Jonesboro until two years after the Atlanta premiere. While many attended the showings, the movie did not attract the kind of attention it generated in Atlanta. Burnham's daughter Amanda reports that she has seen the movie 27 times. The Tara closed in 1957. It was the only theater ever operated in Jonesboro.

Margaret Mitchell was often seen in the Jonesboro area and in Clayton County, talking to residents and researching for her book. She did research in the courthouses of Clayton and Fayette Counties, where she spent hours poring over records and asking questions. She also toured the Warren House during its remodeling, making notes about the soldiers who had written their names on the walls. Later she led Hollywood set designers to see the homes that inspired those in her book.

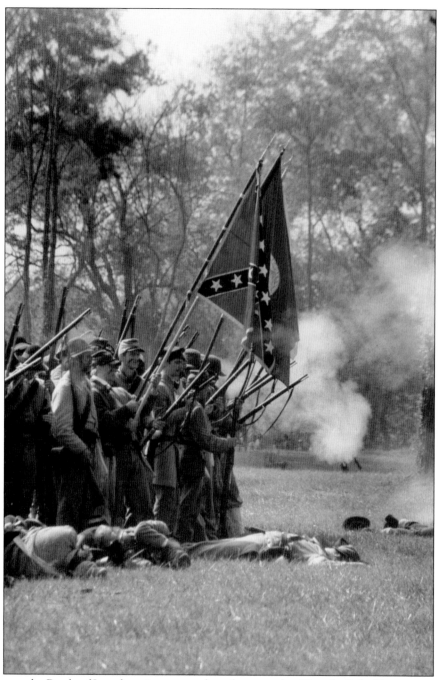

Each year, the Battle of Jonesboro is reenacted on the grounds of Stately Oaks Plantation as part of the fall festivities presented by Historical Jonesboro/Clayton County, Inc. The battle is the highlight of the fall activities in Jonesboro and is attended by visitors, reenactors, and Civil War buffs from all over the country and some foreign lands. The roar of the cannon echoing through the woods can be heard for miles. The smoke from the many guns, the clatter of the horses, and the battle camps of the suttlers (vendors of period items) and soldiers create an atmosphere that takes visitors back to another time.

Nine

CENTENNIAL
CELEBRATION

Jonesboro celebrated its centennial in 1956 with a week of festivities. Citizens dressed in period clothing, including bonnets and hats, throughout the week. The Central of Georgia Railway Company provided a 1860s-era train for display at the depot.

The citywide homecoming began on Monday. The Jonesboro High School Band performed in concert on the courthouse lawn, where Gov. Herman Talmadge delivered a welcoming address. Awards were given to people in the crowd, including the oldest person and the largest family in attendance. The evening concluded with a roll call of Jonesboro men who had served the Confederacy, with descendants answering the call.

Tuesday was designated as Merchants Day. Local store owners decorated their windows with historical displays, which were judged for prizes. There was also a checkers championship, and a barbershop quartet entertained in the evening.

America Day, on Wednesday, started with a *Gone with the Wind* look-alikes contest. A parade marched though town, featuring military equipment, antique automobiles, Scout groups, and floats. The evening ended with a *Gone with the Wind* barbecue and open house at the American Legion Home.

Youth Day, on Friday, began with a rally parade for the Jonesboro High School football game that evening against Henry County High. Everyone was invited to join a horseshoe-pitching contest and a high-time show that was the highlighted of the centennial.

A beard contest was held during Saturday's Fun Day, with prizes for the longest beard, best-shaped beard, and funniest beard. Only beards started after June 1 were eligible. Following the contest, the men were offered free shaves courtesy of Remington Rand Shavers.

Several times during the weeklong event, a pageant titled *This is Your Life—Jonesboro*, written and directed by Eula Duffee and George Waddy, was presented in the high school auditorium.

Old-timers still talk about the wonderful celebration of Jonesboro's 100th birthday. Churches, schools organizations, and businesses worked together to commemorate the heritage of this small Southern town.

Ed Purdy (right) and George Purdy stand in front of the 1922 First Baptist Church following the special homecoming programs that all the local churches held on the Sunday of the centennial. These men and many others were decked out for the occasion.

The men of First Baptist Church gathered for a dinner on the grounds after the homecoming celebration on Sunday morning. Pictured from left to right are O. W. Hooks, Warren Dixon, Bill Casey Sr., Raymond White, Ed Purdy, unidentified, Lamar Wilson, and Harvey Turnipseed.

Miss Atlanta 1956 came to celebrate Jonesboro's birthday. Many of the local men donned Confederate costumes for the weeklong festivities. The Central of Georgia Railroad sent the period train, shown in this photograph, to add to the historical artifacts on display throughout town.

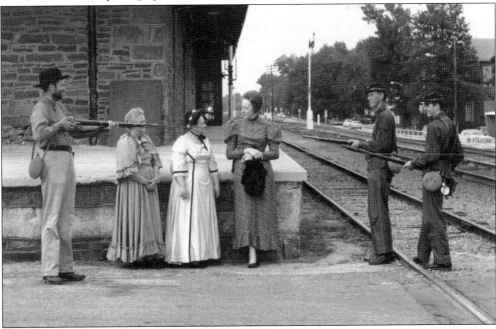

The soldiers appear to be taking aim at each other while the ladies continue with their conversations. The ladies are, from left to right, Fay Adamson, Virginia Evans, and Murdie Betsill. Willis Swint is the Confederate soldier on the left. The photograph was taken at the railroad depot, which was a centerpiece for many of the activities throughout the week.

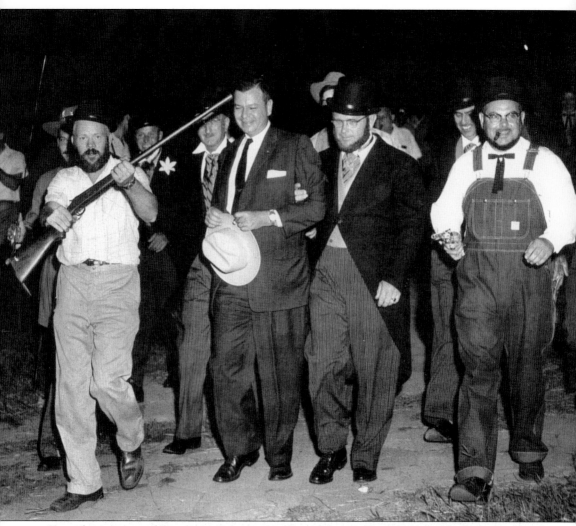

Even the governor of Georgia was not exempt from the centennial law requiring that every man have a beard. Gov. Herman Talmadge was hauled off to appear before the Kangaroo Kourt at the depot. Pictured from left to right are Red McKibben, Pope Dickson, Ed Conkle, Gov. Herman Talmadge, Bernard Foster, Bill Green, Lacy Huie, and Aubrey Roberts. The payment of a small fine would ensure quick release from the makeshift public jail. Even people riding through town who stopped at a red light were carted off to jail.

A parade on Thursday evening was a highlight of the week. Pictured here are the contestants in the Miss Clayton County beauty pageant sponsored by the Jaycees.

Because of the significance of the Battle of Jonesboro, not only to the local citizens, but to the nation's history as well, re-creations of the 1860s were featured throughout the week. During the centennial parade, this group of Union "soldiers" marched down the Main Street, not unlike Sherman's men in 1864. Fortunately this time, the Yankees were not carrying any matches.

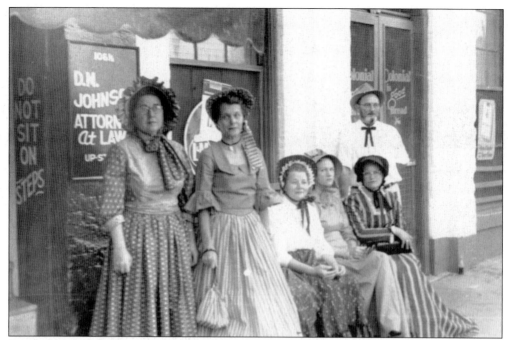

Pictured from left to right are Eddie Mae Matthews, Marion Roberts, Helen Wiggins, Irene Arnold, and Eleanor Foster, who paused for this photograph in front of Wiggins Grocery, which was located at 104 Main Street. The merchants prepared historical window displays for judging.

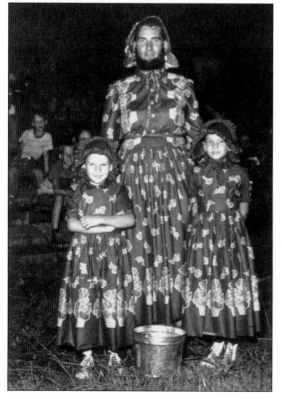

Some very strange people were seen on the last night of the centennial celebration. The Jaycees and the fire department played a game of softball with all of the male players dressed as females. In this photograph, Clifford Wiggins, the fire chief, poses with his sons Jimmy (left) and Bobby in their matching outfits. Jimmy recalls being the water "girl" for the game but does not remember the score.

The contestants in the beard competition line up for the judges in this photograph made in the Jonesboro Drug Store. From left to right, they are Paul Fauscett, Bernard Foster, Dave Gray, Colie Adamson, Clifford Wiggins, Sidney Betsill, unidentified, Philip Jarrell, George Purdy, Robert McMullen, unidentified, Jewell Royston, and unidentified.

The men of the Jonesboro Volunteer Fire Department gathered to display their growth of beards for the celebration. They are as follows: (first row) unidentified, Roger Trammell; (second row) Harvey Jones, Calvin Kemper, Roland Brown, Red McKibben, and Rip Johnson; (third row) Hoke Cartledge, Lamar Wilson, Robert Woodward, Ed Conkle, Clifford Wiggins, Frank Akin, Willis Swint, and Pope Dickson.

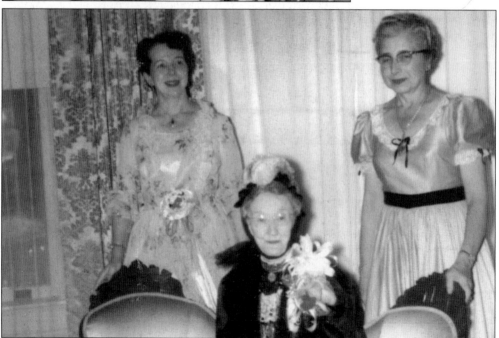

Frankie Arnold Lyle, known at "Miss Frankie," was one of the oldest and best-known ladies in Jonesboro. She was selected as the queen of the centennial. Shown attending to her are Doris Lyle on the left and Sarah Turner on the right. These ladies were active members of the Jonesboro chapter of the United Daughters of the Confederacy. The name was later changed to the Frankie Lyle Chapter.

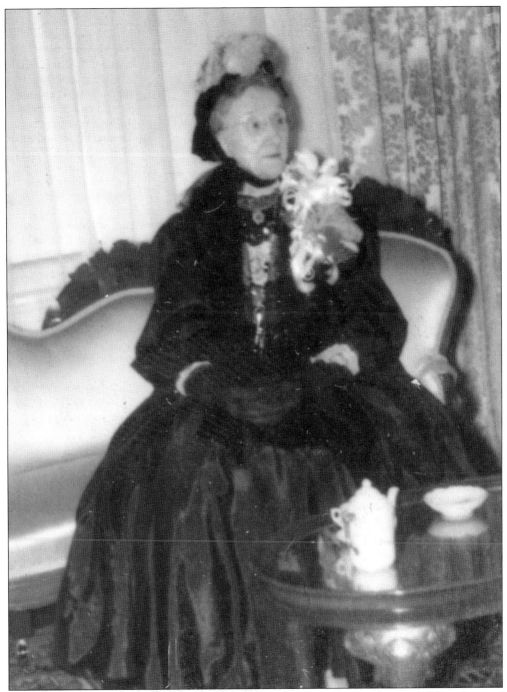

"Queen" Frankie Lyle poses in her centennial gown. In addition to the United Daughters of the Confederacy chapter she organized, Lyle was a founding member of the National Society of Southern Dames of America. A newspaper article reporting on her marriage in 1896 states, "The bride is a charming type of lovely young womanhood, beautiful, refined and amiable, and with a sweet Christian spirit that enables and beautifies her whole life. Her charming personality has won universal esteem and admiration and in social life she has reigned as a belle since her debut."

The centennial celebration stirred a renewed interest in the history of Jonesboro. Eventually Historical Jonesboro/Clayton County, Inc., was organized to preserve this heritage. The first major project undertaken was the relocation and restoration of the McCord House. The Oaks, as it was originally known, was built by Whitmall Allen in 1839. Robert McCord purchased the house in 1858. McCord was serving in the Confederate army when the war came to Jonesboro. Union soldiers camped all around the house and ordered the McCord women and their servants to prepare meals. Later owners included Simeon Waldrop, Richard Wallis, and the Orr family. When an automobile dealership purchased the property, the Orrs gave the house and log kitchen to Historical Jonesboro on the condition that it be moved. The house was cut in half and moved to property donated by the Huie family as the Margaret Mitchell Memorial Park. This photograph shows the house during the restoration.

Stately Oaks, as the house was renamed by the last Orr residents, is today a beautifully restored Greek Revival house museum that welcomes tourists from around the world six days a week. Docents in period-correct clothing offer guided tours. Other buildings were moved to the property when threatened by the bulldozers of developers. The historical community includes the Bethel Schoolhouse, Juddy Roberts' Country Store, a blacksmith shop, a tenant house, and other outbuildings. Buildings of a Creek Indian village have been reconstructed on the back of the property. Special events throughout the year include African American Heritage Day, Native American Heritage Day, Victorian Romance, Mourning and Christmas tours, and the Autumn Oaks Festival and Battle Reenactment. Historical Jonesboro also owns the old jail, which is now the Clayton County History Center, and the Gayden-Webb-Sims House (currently under restoration). Readers are invited to visit Stately Oaks and glimpse life as it used to be in historic Jonesboro.

ACROSS AMERICA, PEOPLE ARE DISCOVERING SOMETHING WONDERFUL. THEIR HERITAGE.

Arcadia Publishing is the leading local history publisher in the United States. With more than 3,000 titles in print and hundreds of new titles released every year, Arcadia has extensive specialized experience chronicling the history of communities and celebrating America's hidden stories, bringing to life the people, places, and events from the past. To discover the history of other communities across the nation, please visit:

www.arcadiapublishing.com

Customized search tools allow you to find regional history books about the town where you grew up, the cities where your friends and family live, the town where your parents met, or even that retirement spot you've been dreaming about.